PETER FRASER

Peter Fraser
The Photographers' Gallery, London
14 June – 27 July 2002

The Photographers' Gallery, 5 Great Newport Street, London WC2H 7HY
Telephone +44 020 7831 1772 Fax +44 020 7836 9704
Email info@photonet.org.uk Web www. photonet.org.uk

ISBN 0 907879 64 0
British Library Cataloguing in Publication Data
A catalogue record for this book is available from the British Library
© The artist, the writer and The Photographers' Gallery, 2002

All images courtesy of Peter Fraser, except p.6 British Film Institute and
p.10 Cheim and Read Gallery, New York.

Editor Jeremy Millar
Text Jeremy Millar
Design alan@axisgraphicdesign.co.uk
Print Editoriale Bortolazzi-Stei Verona

The publication by The Photographers' Gallery of this book and the
exhibition which accompanies it, is a special privilege and opportunity
for me to look hard at twenty year's work. This has been a very
illuminating and sometimes surprising experience which I feel has been
very important. Many people have helped make these events possible,
but a number of them I must name for their contributions. They are Kate
Bush, Elaine Constantine, Michael Mack, Nick and Bunny McMahon,
Jeremy Millar, Marco Santucci, Alan Ward and Paul Wombell.
I thank you all sincerely.

Peter Fraser
www.peterfraser.net

Jeremy Millar would like to thank Rosa Ainley, David Brittain, Kate Bush,
David Chandler, Rebecca Drew, Alec Finlay, Graham Gussin, Mark
Haworth-Booth, Michael Mack, David Mellor, and especially Karen Eslea,
for their advice, support, and patience.

Support for this publication has been received from the Arts Council of
England. The Photographers' Gallery's programme is made possible by
London Arts.

I am very pleased that Peter Fraser has accepted our invitation to exhibit at The Photographers' Gallery and that Jeremy Millar readily agreed to curate the exhibition and write the excellent essay for this book.

For some time I felt there was the need to look again at the generation of British photographers that came to prominence in the late 1970s and early 1980s challenging the orthodoxy of black-and-white documentary photography that dominated the photographic scene of that period.

The exhibition and the book present a very good opportunity to review Peter Fraser's impressive body of work and – for a new audience – to recognise the significant role he played in creating the climate for the importance of today's fine-art photography. At the same time it signals his continuing development as a photographer and his strong commitment to the medium of photography through which he interacts and engages with the world around him.

I would like to thank the Arts Council of England for supporting the publication and also Michael Mack for his kind assistance in this project.

Paul Wombell
Director
The Photographers' Gallery

Jeremy Millar Detour and Access

We can express our feelings regarding the world around us either by poetic or by descriptive means. I prefer to express myself metaphorically. Let me stress: metaphorically, not symbolically. A symbol contains within itself a definite meaning, certain intellectual formula, while metaphor is an image. An image possessing the same distinguishing features as the world it represents. An image – as opposed to a symbol – is indefinite in meaning. One cannot speak of the infinite world by applying tools that are definite and finite. We can analyse the formula that constitutes a symbol, while a metaphor is a being-within-itself.... It falls apart at any attempt of touching it.

– Andrei Tarkovsky, 'Le Monde', 12 May 1983

Over the past twenty years, Peter Fraser has established himself as one of the most important and influential British photographers of his generation. One of the first in this country to recognise and embrace the poetic possibilities of colour photography, Fraser has created an extraordinary body of work while looking, most often, at the most ordinary of things. In describing his practice over this period, Fraser has remarked:

> With each series of photographs I choose a different strategy to approach the same underlying preoccupation, which is, essentially, trying to understand what the world around me is made of through the act of photographing it.[1]

As his comment makes clear, there is an overwhelming coherence in Fraser's approach, albeit a coherence that usually demands new and different forms each time a series of work is developed. These forms are certainly not arbitrary, but emerge from a lengthy engagement between the material and the artist, thereby retaining an important integrity within Fraser's overall practice.

5

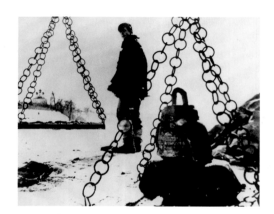

Film Still, *Andrei Rublev*, 1966

Perhaps it is only proper, at this stage, to say what this essay will not do, and that is provide interpretations, detailed or otherwise, of particular photographs. The epigraph, taken from an interview with the great Russian film-maker Andrei Tarkovsky, will perhaps indicate why this is so. Tarkovsky is an extremely important influence for Fraser, and the images that each creates often work in similar ways, that is, as images full of meaning. Their images do not fully articulate these meanings, however, nor do they act as symbols or allegories, where the viewer is directed away from the image in order to find meaning on some other, usually higher, plane. That is not to say that an audacious viewer might not wish to interpret them symbolically – the casting of the bell in *Andrei Rublev* (1966) as the spiritual transformation of matter into the immaterial, for example – and yet while in such work the image will always retain meaning far in excess of that which it has been given, one often can't help but feel that a damage has been done to it. Instead, this essay will look at a number of the major series on which Fraser has worked over the past twenty years and suggest, rather than determine, a number of ways in which they might be considered. Given the enormous shifts in our understanding of photography that have occurred during this time in Britain, I shall, on occasion, emphasise the context in which the work was made, in order that we might better appreciate the shifts within Fraser's own practice. At other times, I shall refer to historical writers, or recent films, if it is felt that there might be useful parallels to be made. Yet nowhere are these references to act as validations or confirmations of any

particular reading, and while all writing on art is inevitably a form of closure, I hope that the work might open for as long as possible.

In 1983, Fraser began work on a project that would come to mark a significant development in his practice, *Twelve Day Journey*. The journey had no itinerary and only the vaguest sense of direction, beginning at St Just in Cornwall, a couple of miles from Land's End, a place that may be considered the land's beginning also. Each morning Fraser would decide upon a general direction of travel – which inevitably, near the beginning at least, would be north-easterly – and set out, never quite knowing where he would end up or how we would get there, subject to the vagaries of walking, hitch-hiking and public transport. Although the framework of this project was relatively rigid, what happened within it could be in no way determined or foreseen; as Fraser has noted, it was

> basically just a simple device to minimise the interference with the process of photographing – I gave myself twelve days travelling, never knowing how, or where, but being able to concentrate twenty-four hours a day on making pictures, without interruption.[2]

We might consider it differently, however, as a means by which interference and interruption – a passing bus, or an unexpected path – could be accepted as part of the journey, as something that *becomes*

the journey rather than merely a disruption to it. Fraser has remarked upon the liberating nature of the journey, and it is a mode that encourages an important degree of openness in the traveller, an openness that, in turn, encourages the traveller to become sensitive to that which surrounds them. As such, it is a mode that has appealed to artists and writers for some considerable time.

As Leslie Stephens was to write in 'In Praise of Walking' in 1902, the 'literary movement at the end of the eighteenth century was ... due in great part, if not mainly, to the renewed practice of walking'.[3] The importance of pedestrianism to the Romantic poets, and the young Wordsworth in particular, not only led to a greater appreciation of the English landscape but also, in a sense, showed how this appreciation might be created. More recently, this sense of engagement has been absorbed within the more conceptual practices of artists such as Hamish Fulton or Richard Long, both of whom have made walking the very medium of their work (or 'the walk is the work', as Fulton has it). This is certainly not the case for Fraser – the photographs are the work here – but the form of the walk certainly shaped the form of the work, and in particular the way in which the artist 'looks'. As the historian Eric Leed has noted, the traveller moves through a 'perceptual envelope', the shape of which changes according to the speed of travel (the envelope 'elongates into a tunnel as the speed of passage increases').[4] At speed, the outside world disappears, or is shaped by the will of the traveller; for the pedestrian, however, or the traveller whose passage is a form of 'active surrender' to the landscape and its

circumstances, the world begins to reveal itself, or as the poet Thomas Clark has written, in a work which shares its title with Stephens' essay:

> The pace of a walk will determine the number and variety of things to be encountered, from the broad outlines of a mountain range to a tit's nest among the lichen, and the quality of attention that will be brought to bear upon them.[5]

The moderate pace of the pedestrian traveller is indeed liberating, as Fraser noted, in that it allows for the freedom to stop and look, to wait, to linger; consequently the mind is able to wander also:

> Wrong turnings, doubling back, pauses and digressions, all contribute to the dislocation of a persistent self-interest.[6]

Rather than actively looking for 'something' to photograph, then, here Fraser's attention is marked by a certain receptivity, allowing the world to make itself known — and perhaps to some degree knowable — to him. In this regard, he does not simply turn towards what might be considered the more conventionally 'beautiful' — of which there is much in Cornwall — but is able to find beauty elsewhere, in the unexpected, where he might not otherwise have looked.

That this work was first seen alongside the work of William Eggleston at the Arnolfini gallery, Bristol, in early 1984 was more than appropriate, given the enormous influence that the American photographer had upon Fraser's conception of what photography might be. Before we consider this, however, it might be useful to go back further, to Fraser's time as a student at Manchester Polytechnic between 1972 and 1976, and the people shaping his understanding of photography at that time. Although the course was designed, mainly, to produce commercial photographers, a few students who shared a passion for the medium — such as Martin Parr and Brian Griffin, as well as Fraser — began to look at the work of a number of American photographers — Minor White and Ansel Adams, or Robert Frank, for example — that were slowly becoming more accessible through publications. That Fraser and other photographers of his generation came into contact with, and were heavily influenced by, such work was hardly surprising, given the dominant position of American photographic practice since the Second World War. Perhaps as important as the photographers themselves were the curators and writers that promoted them — the directors of the Photography Department of the Museum of Modern Art in New York, Beaumont Newhall and John Szarkowski in particular. Although their approaches were different in a number of important ways — and different too from Edward Steichen, whose directorship separated them — nonetheless, they helped establish a form of photographic modernism which, although heavily contested since the 1970s, arguably remains dominant to this day. For Newhall and Szarkowski both, photography was to be freed from its historical specificity and allowed instead to occupy a curiously timeless 'everyday' (because every day is

'everyday'). And so the campaigning work of a liberal reformer like Lewis Hine – whose photographs made visible the real labour cost of America's rapid industrial expansion – was removed from magazines and pamphlets and framed upon gallery walls; likewise the majority of photographs included in Walker Evans' 1938 solo exhibition at MOMA, curated by Newhall, were made during the previous few years for the Farm Security Administration as documents of the poverty of migrant farmers in the South, although one would not have been made aware of this through either the exhibition or its accompanying book. Once more, the specifics of time and place were removed, and the viewer was encouraged to consider the photographs as particularly elegant and open examples of an ongoing American vernacular. In order that the photographs be so transformed, the role of the photographer must be transformed also. No longer a simple recorder of the 'real' found before his (usually his) camera, the photographer now became an artist whose poetic sensibility allowed the everyday to reveal its own transcendental beauty without the need for any significant intervention. As such the inherent characteristics of the medium – another modernist dictum – such as its visual clarity and technological impersonality could be elevated as personal style, albeit one that was resolutely anonymous. The appeal of such a position for almost any young photographer hardly needs explaining, or as Fraser now recalls it:

> I knew at the end of the first year that I wanted to work from a direct experience of the world and did not want to set things up.

This seemed to me to be by far the most profound challenge – to try to say something interesting about the experience of the everyday that we all have, or feel we that we all have, regardless of the specifics.

By 1981, after a few years in Holland and Hebden Bridge, Fraser was back in Manchester. His work at this time explored the surrounding urban environment and was made using a 5"x4" camera, which necessitated a slow, considered approach. Consequently, the photographs themselves are formally composed, and somewhat static, the streets curiously empty. However, perhaps what was most important about the work at the time – and something that, curiously, is almost invisible to a viewer today – is that it is in colour. After a couple of years of thinking about and looking at art, rather than making it, Fraser had come to realise that he 'simply didn't see the world in black-and-white and that was that'. The absolute control of the medium that photographers such as Ansel Adams and Edward Weston demanded, and which black-and-white practice made possible, was beginning to seem less important for the sort of photographs Fraser wanted to make. Clearly inspired by the photographers associated with the 'New Topographics', and the work of Stephen Shore and Joel Meyerowitz in particular, Fraser began to scrutinise his surroundings, and place them within a rigid frame.

Fraser felt that his move into working with colour was more than validated when the following year, 1982, he came across a copy of

9

REGARDING WORKING W/ THE EVERYDAY

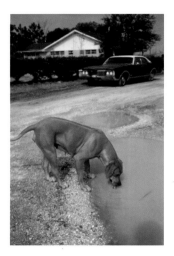

photograph from *William Eggleston's Guide*, 1976

William Eggleston's Guide, the publication which accompanied the now legendary exhibition at MOMA in 1976. The book had a profound affect upon Fraser:

> I did not believe that it was possible to talk about the kinds of things that Eggleston's photographs talked about using photography – in other words a whole new world of possibilities opened up. And what was fabulous was if that was possible, then what else was possible? Up until that point, the potential of photography to engage with a person's response to the world around them seemed to fall within tightly constrained and, to my mind, relatively predictable areas, but here was somebody who could almost photograph a smell – he could almost photograph something that was impossible to photograph and that was, and still is, an idea which for me is incomparable. It opens up the future of photography, of everything that can come afterwards.

What came afterwards for Fraser was that he bought a Plaubel Makina 6x7, a hand-held medium-format rangefinder camera that granted him the freedom so evident in Eggleston's work. This quickly became apparent in Fraser's photographs also, which became far less rigid and, although seemingly more casual, actually possessed a far greater intensity of looking than had been previously the case. Eggleston had already taught Fraser a great deal; Fraser thought that he might learn

even more if he could work with Eggleston in his own environment.
Now, he only had to meet and ask him.

The opportunity arose when Mark Haworth-Booth, curator of
photographs at the V&A, organised a small exhibition – a 'pocket
exhibition' as he described it to Eggleston – of the American's work.
At the opening reception, Fraser introduced himself to Eggleston, and
asked whether he might be able to work with him in Memphis.
Eggleston asked him whether he worked in colour (yes) and whether
he taught (no – he wasn't teaching at that time) and as a consequence
Eggleston agreed, to the surprise of the few people who knew Fraser's
intentions that evening. The following summer of 1984, following their
parallel solo exhibitions at Arnolfini, Fraser travelled to Tennessee,
not knowing how long he would stay there. He returned after two
compelling but difficult months. At the time, Fraser saw the visit
almost as test of his commitment to the medium of colour
photography, which no doubt created its own difficulties for
Eggleston, who was unlikely to have been interested in participating in
such a test. Nevertheless, the time spent there further confirmed to
Fraser the importance of – and the possibilities for – the practice to
which he was now so fully committed.

It might be argued that a question once asked by Henri Lefebvre –
is it not in day-to-day life that the truth in a body and a soul must be
grasped? – is one to which Fraser has turned throughout his career,
although perhaps most clearly in those series collected in his first
monograph *Two Blue Buckets* in 1988. The title of the book was taken

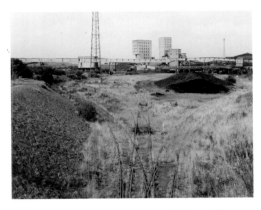

Peter Fraser, *Untitled*, 1981

from a photograph in his next series, *Everyday Icons* (1985–6), in which two blue buckets – similar and yet different – seem to float upon the empty blackness of a classroom floor. Although the photographs themselves share much with *12 Day Journey*, the series has a clearer intent than its predecessor. Fraser decided to explore the possibility of what he termed 'personal religious experience' occurring within everyday life, as opposed to the formalised sanctity of the Church. Although, as before, Fraser used the device of a journey through the south west of England to structure the work, here there was also a greater degree of intention. Rather than aimlessly wandering over a fixed period of time, Fraser made a specific journey: from the cathedral in Bristol (where he was now living) to Glastonbury Tor, via Wells, another cathedral city. He made the journey on foot at various times over a period of eighteen months. The direction of the journey is important, I think. Starting with an architectural manifestation of organised religion, Fraser's journey could be seen as one that went backwards in time, past even the myth of Joseph of Arimathea burying the Holy Grail just below the Tor, to druidic and megalithic times, when Glastonbury was already a place of pilgrimage. The cathedral and the Tor mark the beginning and the end of the journey although they do not appear in the photographs themselves; indeed, there are no familiar landmarks in the series of fifty works. As Fraser wrote of the project at the time, 'The sacred is everywhere and resides in the most unlikely places',[7] and so we find him taking photographs, in the churches that line the route, yes, but also in

farmyards, pubs and gardens. As such we might find in this work a response to the challenge posed by the American transcendentalist Ralph Waldo Emerson in his 1841 essay, 'Art', that:

> It is in vain that we look for genius to reiterate its miracles in the old arts; it is its instinct to find beauty and holiness in new and necessary facts, in the field and road-side, in the shop and mill.[8]

In this light, perhaps we might see Fraser as part of a long and interesting tradition, a tradition that runs past Emerson even, towards Wordsworth and beyond. In his fascinating book *Into the Light of Things*, George J. Leonard explores what might have influenced the young Wordsworth to find Paradise, 'A simple produce of the common day'. Leonard suggests that it was Archibald Alison's *Essays on the Nature and Principles of Taste* (1790), a book long forgotten but extremely influential in its time, that provided Wordsworth with the encouragement to create a poetry of the everyday. Even within the first handful of pages of this book, Wordsworth and other young radicals would have read that there is a difference between ordinary sight and awakened sight which is accompanied by an 'operation of the mind', beauty and sublimity only becoming available to those that exercise their imagination so. Perhaps most interestingly, Alison states that 'sublimity' and 'beauty' are not properties of objects but 'emotions' that we have about them (and therefore that no object has

greater aesthetic value than any other), that the beautiful and the sublime are:

> almost constantly before us; and not a day passes without presenting us with appearances, fitted both to charm and to elevate our minds; yet it is in general with a heedless eye that we regard them, and only in particular moments that we are sensible of their power.[9]

An aesthetic of the everyday was slowly beginning to take form in literature and in painting too – John Constable called the final chapter of Alison's book by far the most beautiful thing that he had ever read. Perhaps we might now say that it was only with the development of photography that this aesthetic approached its true potential.

Fraser was exploring this potential in another series he was making simultaneously, *The Valleys Project* (1985). Organised by the Ffotogallery in Cardiff, The Valleys Project was a series of commissions given to a variety of photographers over a number of years, in order to create a broad picture of life in the Welsh valleys. In many ways Fraser was an obvious choice for such a commission – he was born in Cardiff and went to school in the Rhondda valley – and yet his photographs were very different in approach to the gritty black-and-white 'realism' that characterised 'serious', and 'seriously-engaged', practice at that time. There is a degree of ambivalence in Fraser's photographs for what had been his home for so long; a fondness certainly, but also a sense of despair at what had become of it. Even the humour to be found in the photograph of a green shed, surrounded by grass and trees, on which is graffiti'd 'I hate GREEN', is as black as the paint in which the declaration is made. In many of the other works, also, there is a barely concealed violence: images of separation, dislocation, of things discarded or dumped. It is important to remember that this was a time of great difficulty in the Welsh valleys, as for many other (especially industrial) parts of Britain, as the Thatcher government wrecked communities with a dry-eyed vindictiveness. Fraser recalls driving around the area while working on the project and being shocked by the large groups of men hanging around on street corners in the middle of the day perhaps waiting for something to happen, or trying to understand what already had. The photographs he produced are images about great potential – whether ignored, wasted or waiting to be realised. Fraser has remarked that this series is probably as politically engaged as his work will ever become, and there is undoubtedly an overwhelming despair at the needless waste that he encountered. What is particularly interesting, especially in the context of British photography of the mid-1980s, is that this was so sensitively explored through images of quiet, reflective intelligence.

It is perhaps difficult now to recall, or to imagine, but this was a period of great debate on the relative values of photography in Britain, and much of that debate was to be had in the pages of the magazine *Creative Camera* (one might add: their editorial meetings also). As its last editor, David Brittain, has noted, 'In the early 1980s *Creative*

Camera became a kind of trope for photography itself which might be 'claimed' by the eventual victor of the battle between ideologies.'[10] On being appointed co-editor during the spring of 1984, Susan Butler decided that the magazine should act as a forum for the plurality of voices and opinions that were being expressed at the time, and in particular the dominant opposition, as she recalls, 'between staged/PCL [Polytechnic of Central London] work, on the one hand and 'straight'/documentary on the other'.[11] It was Butler's intention to bring together these seemingly divergent camps in order to 'disperse, or reconfigure, the narrowly-drawn battle lines of photographic debate in Britain'.[12] Her imagery is hardly accidental, as the discursive space that was opened up soon became a field of unthinking entrenchment and bitter sniping.

The increasing development of colour practice at that time polarised opinion further, although not necessarily along the lines already identified. For some, colour was the language of commercial imagery and therefore did not belong within the precincts of photographic art. Even a photographer of the undoubted sophistication of William Eggleston, whose pictures were almost quintessentially modernist, was considered irredeemably vulgar by many so-called traditionalists. (The furore that surrounded Eggleston's 1976 MOMA exhibition was played out again, in its own small way, during his 1983 display at the V&A. The curator, Mark Haworth-Booth, recalls the picture editor of a prestigious Sunday supplement asking why he had wasted his time bringing him these snapshots. Haworth-Booth also received a letter

from a prominent photographer, asking him to consider the ways in which the exhibition might permanently harm his reputation. Of course, we can now see that in its own way, it was one of the most influential photography exhibitions in Britain over the past twenty years.) For others, it was this very connection with the world outside the confines of photographic art that made the use of colour so necessary, and so urgent, as a means of examining the structure of photographic meaning (something that did not necessarily coincide with the making of meaningful photographs). We might also identify another group of people, also committed to developing a new colour practice, albeit one that emerged from a recognisable documentary tradition. By using colour, they believed it possible to revive a documentary practice that had become hackneyed and formulaic. In some cases this did not necessitate an overhaul of the types of images themselves, and familiar styles were colourfully reworked; in others, the response was straightforward and unapologetic. As Paul Graham made clear in an interview from 1986:

> It really is time for this question [of the use of colour] to be reversed, because it is those in black and white who should be defending themselves — it is they who are deliberately reducing the world to a grey scale, and consequently it is they who have the explaining to do.[13]

Nevertheless, it was the supporters of the 'new colour photography',

as it became known, who felt the need to explain themselves, as in Susan Butler's 1985 article, 'From today black and white is dead', which suggested that 'colour can now provide a vehicle for the expression of a range of contemporary concerns and the expansion or transformation of traditional ones as well'.[14] While Butler acknowledged the irony of reworking Paul Delaroche's statement, made upon the announcement of photography's invention, 'From today painting is dead!', its use cannot help but suggest that positions were being established, and oppositions made, in much the same way as they had been nearly one-hundred-and-fifty-years previously. Could the intervening period really suggest no useful alternatives to this polarisation? One can only speculate how much more interesting, and useful, it might have been had the discussion considered instead the practices of 'film essayists' such as Chantal Akerman, James Bening, Babette Mangolte, Chris Marker, or Jonas Mekas, to name but a handful. However, to discover that many of the issues about which one is arguing so passionately have, to some extent, been resolved— and by cinema, photography's brash sibling! — might not have been so greatly appreciated at the time.

The position of Fraser's work within these arguments was unclear and, consequently, it was not a particularly comfortable time for him. Although firmly committed to a practice of colour photography, Fraser had little interest in following the polemical 'image-making' of Victor Burgin or Yve Lomax, and yet his work sat uneasily within the documentary traditions that photographers such as Paul Graham and Martin Parr were, in their very different ways, then exploring. This is not to say that Fraser was without his supporters, however. Peter Turner, who became editor of Creative Camera in 1986, considered that Fraser's practice brought together the developments of the 'new colour photography' while also forming a continuity with what had come to typify more 'traditional' concerns of seeing by means of a camera. The cover of Turner's first issue as editor contained Fraser's aforementioned, 'I hate GREEN', a colour image that contains the declaration of a hatred of colour, and thereby characterises much of the ambivalence of the period.

In 1986 Fraser had a solo exhibition at The Photographers' Gallery in London in which he showed *Everyday Icons*. Having now shown this work, Fraser felt that he had cleared the mental space necessary in order to create a new series of work, which became *Towards an Absolute Zero* (1986). As has been the case in a number of his series, Fraser was unsure what it was he wanted to do next although he knew — a valuable lesson from college — that the best way of establishing what to photograph is to make photographs. Although Fraser's work had always depended upon an accumulation of allusions rather than any straightforward symbolic meaning — despite the iconic status that was afforded the green shed and the two blue buckets — it was in this series that Fraser set out deliberately to develop a broad range of possible meanings through spatial relationships, repetition, and juxtaposition. By placing the photographs in diptychs, triptychs and other sequences, and by often repeating an image within different

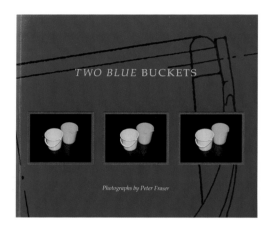

Peter Fraser, *Two Blue Buckets*, 1988, Cornerhouse Publications

sequences, Fraser began to explore more clearly how meanings might be created through the play of images. Rather than attempting to fix meaning, however, or hold it under interrogation, as some photographic artists seemed to be doing at the time, Fraser allowed it a freedom within the conceptual space he had created within and between the photographs. It is this belief in the generative importance and richness of ambiguity that can perhaps relate these works to Umberto Eco's influential notion of *opera aperta,* or the open work, a theory of semiotics that insists upon multiplicity, plurality and polysemy in art. As Eco makes clear, openness is:

> the guarantee of a particularly rich kind of pleasure that our civilisation pursues as one of its most precious values, since every aspect of our culture invites us to conceive, feel, and thus see the world as possibility.[15]

This openness at the very heart of Fraser's work was further emphasised when images from *Towards an Absolute Zero* were included in his monograph *Two Blue Buckets* (1988) alongside images from the earlier projects we have discussed. Although consisting of distinct series, one of which was commissioned, the photographs that we find in the book seem always to spill from their specific contexts. One begins to imagine an image from *Everyday Icons* within a triptych from *Towards an Absolute Zero*, the suitcase perhaps, or that the twelve-day journey might have passed through the valleys instead.

While reviewing the book, with typical panache, Ian Jeffrey remarked that, 'a propos Fraser, photography is the only medium in which art can amount to anything in the 80s' although '"Art", despite its presence, has nothing like Fraser's range, and this collection/work will have more to it than any piece or collection of current pieces put on in any major venue for years ahead'.[16] Fraser's book was not simply the mark of a significant achievement within contemporary British art but also, through its very ambition, influenced a new generation of young photographers. It remains one of the seminal publications of post-war British photography.

In 1990, Emma Dexter, then Director of Exhibitions at the ICA, London, commissioned Fraser to spend six or seven weeks during the summer in Marseilles in order to make a new series of photographs. One of the first things that he noticed upon arriving, particularly when he travelled around the outskirts of the city, was the incredible intensity of light there. Everything seemed to shimmer. For the previous couple of years Fraser had been using a Rolleiflex to create his most recent series of triptychs – a series that had developed from his explorations in *Towards an Absolute Zero* – and he began to use it in Marseilles also. As had been the case previously, while using the 5"x4" or the Plaubel 6x7, the camera itself both encouraged and enabled a certain way of working, and of looking. As the Rolleiflex has two lenses, what is seen looking down onto the viewing screen comes from a lens placed just above that which makes the exposure. As the lens through which one views is set to an extremely wide aperture, to allow as much light as possible into the screen in order that one can view the scene most clearly, the depth of field of the image – the plane within the image that is in sharp focus – is at an absolute minimum. Put simply, while looking through the viewfinder, and especially when the object focused upon is in the mid- to foreground, only a very shallow area of the image is ever completely sharp: everything that lies before and beyond it will be out of focus. As Fraser looked through the viewfinder, objects and scenes seemed to dissolve before his eyes just as they appeared to do within the intense heat and light of a Mediterranean summer. Fraser decided to adopt this technical characteristic, and the use of an extremely shallow and selective focus became a motif in the series. As Fraser looked at objects and architectural elements, shimmering in the air before him, it seemed as if their outlines were becoming unclear, that their edges were dissolving into the air around them. It was this that Fraser decided to try and photograph, something that was almost impossible to photograph – the space around and between objects. Of course, we can make out certain elements quite easily – the wires grasping from a textured wall, or the chipped, flat rocks which lie upon the smooth, scarred surface – yet we never quite feel as though these are the subject of the photograph, but rather a function of that which is the subject, namely, the surrounding space.

The eventual title of the series, *Ice and Water*, has an interesting relationship to that of the series, *Towards an Absolute Zero*, in that

both draw upon ideas inspired by science. The earlier work alludes to the concept within theoretical physics that at absolute zero, a temperature of −273 degrees centigrade, all atomic activity ceases. What intrigued Fraser about this notion was that the 'discovery in a "still" universe of material just a few degrees above absolute zero would be momentous. The minute shift carries importance because of its proximity to a threshold at which nothing happens.' What this meant in terms of his own practice was that the more 'still', or reduced, an image became then the greater the effect of the most minute alterations, that 'the smallest details can carry substantial psychological value'.[17] The title *Ice and Water* is taken from an example in another branch of physics, complexity theory, of a concept called 'phase transition', where an object does not lie static in one of the three classical physical states — solid, liquid, gas — but seems to rest between them, a stage rather than a state. While it may seem an unusual position, it is actually quite common, the example usually given being the melting of an icecube. Within the cube itself, the molecules are locked within a rigid crystalline structure, an ordered condition; within the fluidity of the water, its form and ease of mobility represents a state of inconstancy. But in between these states, between the order and the inconstancy, there is a stage where the ice is just melting, where water lies upon its surface, while the ice floats in the water that now surrounds it. This is the phase transition between ice and water, between solid and liquid, between two seemingly quite separate elements.

Like the notion of transformation in *Towards an Absolute Zero*, that which can be found in *Ice and Water* also encourages a scrutiny of the world around the viewer, albeit a scrutiny that demands both intensity and sensitivity. Fraser has suggested that it was not simply the technical characteristics of the camera — its shallow depth of field and its square format — he was using that provoked this intensity but also the fact of spending a great deal of time alone in a country in which he could not easily communicate. In such an environment, one might feel as though one could disappear without being noticed, and it is the possibility of disappearance, of absence, that makes the experience of presence so extreme. I think that it is this intensity that encouraged Fraser to intervene in the image in ways that he had not done so previously. Whereas his earlier work was distinguished by a complete lack of perceived interference in the image, something Fraser thinks relates to his preference as a child to observe rather than participate, in this series the photographer's intervention is especially apparent. This is not only true with the use of selective focus, as discussed, but also in the intense framing of the image and the exaggeration of certain colours. This is certainly the case with the photograph of some cardboard boxes that were found stacked at the rear of a church. As he made the exposure, Fraser knew that the photograph would not be printed in such a way as to replicate its appearance to the eye, but rather in such a way as to allude to how he saw them imaginatively, in a way that suggested the irrational. As such he decided 'to print it in such a way as to suggest large forces at work that were way beyond my

comprehension or understanding', which suggested that it become a deeper and deeper blue. While this series might appear to be radically different in both approach and form to those that came before it, instead they share a fundamental similarity, that is, an engagement with the world based upon its own incongruity, or the 'impossibility of everyday life' as Fraser has called it. Fraser's engagement with the world is one founded upon a curiosity, 'a curiosity', as T.S. Eliot remarked, 'which recognizes that any life if accurately and profoundly penetrated is interesting and always strange.'[18]

It was not until *Ice and Water* had been exhibited and published in 1993 that Fraser began work on a new project. Prompted by some of the scientific ideas suggested by his previous two projects – the nature of observation, for example, or the relationships between differing materials – Fraser began to make some new photographs that looked at man-made objects and how these objects, to some degree, formed our engagement with the world. After a year working on the project Fraser was dissatisfied with the results. At the time he dreamt that he asked Andrew Cross, the then curator of the James Hockey Gallery where Fraser had shown *Ice and Water*, whether he had a scaffold platform at the gallery that could be set up and photographed. Fraser followed the somnambular suggestion – the gallery did have such a platform – and Fraser went off to photograph it. It was only at this point that he noticed the manufacturer's stamp on the side: 'Gravity'. To Fraser this was a gift, and he took it as indicative of the direction the work should now take.

Fraser began to conceive of a series of photographs of specialised technological objects and set about making the necessary arrangements, approaching various companies, government agencies, and university research departments. Once access was granted to these environments – which often took some time and no little persuasion, particularly given the commercial sensitivities of the research underway in these places – Fraser began to make *Deep Blue*, a series of photographs which possess an extraordinary precision and clarity.

These photographs appear as different from those in Ice and Water as that series does from the series that preceded it, although one should not confuse visual disjunctions with conceptual ones. For all their undoubted technical sophistication, their extraordinary value, and the obstructions we might face in gaining access to them, these objects can quite reasonably become situated within a poetics of the everyday, as previously outlined. It must be obvious that the notion of the 'everyday' is one that is subject to continuous change – what is commonplace now might not be so in the future. This was certainly clear to Wordsworth when he wrote in 1800 that 'if the labours of Men of Science' should ever lead to 'any material revolution' in our lives and what we 'habitually' see and hear about us, then 'the Poet will sleep then no more than at present', 'carrying sensation into the midst of the objects of the science itself'.[19] Although for Wordsworth the everyday consisted, for the most part, of nature, he could see that 'if the time should ever come' when the objects produced by even 'the

remotest discoveries of the Chemist, the Botanist, or Mineralogist' are a 'familiar' part of our lives, then 'these things ... will be as proper objects of the Poet's art as any upon which it can be employed'.[20] That said, Wordsworth himself did not feel comfortable, in later life, in taking up the challenge he had himself laid down to the poets of the future, though Walt Whitman did. Writing in the Preface to the 1855 edition of *Leaves of Grass* Whitman states that 'Exact science and its practical movements are no checks on the greatest poet but always his encouragement and support. Science underlies the structure of every perfect poem.'[21] It is hardly surprising that Whitman — the poet of a new country and a new age — became such an important figure for the artists and writers of the Cubist and Futurist period.

The declarations of the Futurists are by now so familiar — and are reprinted in every advertisement for every car and every computer in every newspaper and every magazine — that they do not need to be rehearsed here. We are as used to recognising beauty and elegance in machines as we are in nature, indeed perhaps more so by now, and it can quite obviously be found in Fraser's seductive photographs. Indeed, we can find it twice-over here, as we must delight in the immense sophistication of the machines through the precision and clarity of the photographs, themselves a machinic paean to the beauty of technology. These photographs are more than simply images of desire, however — though Fraser does not pretend to hide their undoubted alluring qualities I think they suggest something much more anxious and uncertain.

When Fraser began talking to the scientists and engineers engaged in the development of the machines he was photographing, he sensed that they were trying to create objects of such complexity that they were imbued with what we might only call 'intelligence'. Of course, the notion of an intelligent machine has filled dreams, and nightmares, for centuries, although perhaps it appears all the more appropriate now given the extraordinary developments in computer technology over recent decades. It was as a consequence of these conversations that he began to conceive of these photographs as portraits, and portraits that were helping to define a newly emerging class, just as they had done historically. By referring to these photographs as portraits, rather than still-lifes for example, Fraser seems to be placing these photographs above those taken in earlier series of other objects. The objects are considered with a mixture of awe and trepidation, courtesy and reverence, and indeed Fraser does refer to one of the photographs (of a mapping satellite) as suggesting a throne. What I find most interesting, however, is that while making this work, Fraser could not help but think of HAL, the computer from Kubrick's 1968 masterpiece, *2001: A Space Odyssey*.

HAL is quite possibly the most complex — and certainly the most well known — representation of a thinking, conscious machine in modern times, and in many ways embodies our most profound desires and fears in our relationship with technology. That this would suggest an ambivalence at the heart of Fraser's project is confirmed, I would suggest, by his choice of title, *Deep Blue*. In May 1997, Deep Blue, an

IBM supercomputer, beat Garry Kasparov at chess, the first computer to defeat a world champion. For over fifty years, 'Programming a computer for playing chess', to quote the title of Claude Shannon's seminal 1950 article on the subject, has been seen as an ideal way of working upon some of the problems associated with machine intelligence. As Shannon notes:

> The problem is sharply defined, both in the allowed operations (the moves of chess) and in the ultimate goal (checkmate). It is neither so simple as to be trivial nor too difficult for satisfactory solution. And such a machine could be pitted against a human opponent, giving a clear measure of the machine's ability in the type of reasoning.[22]

We also see HAL playing chess with the astronaut Frank Bowman, indeed beating him with a flair and degree of risk-taking that would suggest a human rather than computer player. What is perhaps most interesting in this short scene, as pointed out by chess Grandmaster Larry Evans, is that in relaying his winning moves — a Queen sacrifice — HAL said 'Queen to Bishop Three', whereas the correct call would have been 'Queen to Bishop Six'. Perhaps this was just a simple mistake in the film (there are a number of them after all), or perhaps it was an early, subtle example of the computer's fallibility. In any case, Bowman did not notice. He wasn't looking for such mistakes as he assumed that HAL did not make them, and in any case, defeat seemed inevitable.

This was not the case for Kasparov, however. There were horrified gasps in the audience. Kasparov did not expect to lose and, as his computer advisor Frederick Friedel acknowledged, he was devastated. The news spread around the world, that a computer had at last beaten the world's best in a game of intelligence, memory, imagination, passion and intuition. For *Time* magazine the defeat was not simply world historical: 'It was species-defining.' The reaction was in many ways entirely predictable (it was an echo of the reaction of many of the scientists at Los Alamos after the devastation of Hiroshima and Nagasaki), a perverse, compelling delight in the creation of something that will then threaten us, whether it be our supposed intellectual superiority or our continued planetary survival. The photographs of *Deep Blue* are photographs of a similar apprehension — the apprehension of knowledge, and the apprehension of what might be done with it.

In his most recent book, philosopher Hilary Lawson introduces one of his chapters as follows:

> Science no more uncovers the true nature of the world than day-to-day description, and its closures are subject to the same pressures as less precise and defined terminology.[23]

The chapter in question is titled 'What is the world made of?', a question I believe Fraser has been asking throughout his practice, perhaps never more so than in his most recent series, *Material*, which

brings together those descriptions of the world – both scientific and day-to-day – that Lawson suggests. While working upon the photographs that became *Deep Blue*, Fraser became fascinated by the extraordinary lengths that were taken to exclude the outside world from the environments in which these hi-tech machines were constructed. Through the use of extraction units, filters, air-locks, and protective clothing, dust particles and other 'undesirable' pieces of matter were prevented from entering these 'clean spaces'; even in those environments where the very nature of matter is interrogated – such as the particle-accelerator at CERN, for example – matter must be controlled before it can be understood. Fraser began to consider what this might mean for any attempt to understand the world – and what it is made of – and so began to make a series of photographs of dirt, dust, detritus, which would be placed alongside new photographs taken in laboratories and technical workshops.

If the laboratory procedures are indicative of the value our society places upon different materials (Freud quoted the statement that dirt is matter in the wrong place), Fraser's camera makes no such distinctions, no such judgements. Fraser has spoken of 'the democracy of materials', and here everything is worthy of the same intense, considered attention regardless of its perceived status. The fringed edges of scurf become as delicate as the tracings upon a circuit board, an accumulation of hair and fibres as fine as a web of copper wires. The viewer might be reminded of the sculptural concerns of Robert Morris, with his notion of *anti-form*, which we find in the 1968 work,

Untitled (Threadwaste), or Robert Smithson's explorations of entropy, in *Glue Pour* (1969) or *Asphalt Rundown* (1969), for example, and in many ways Fraser shares these artists' fascination with the interactions and processes of the material and its place in the texture of the world. Jean-Paul Sartre referred to the 'sticky' as essentially ambiguous because its fluidity exists in slow motion (one might think also of *Ice and Water* in this regard). The materials in these pictures often do not seem fixed or static in any meaningful sense either but, in Fraser's words, are 'striving for another state'.

That these materials exist, that they were in a certain state at the time that they were photographed, that they were photographed at all, are all forms of 'closure', as referred to in the quotation from Lawson above. By 'closure', Lawson refers to the process by which meanings, ideas or objects come to be formed out of 'openness', that is, infinite, indistinguishable, undifferentiated potential (although to define openness in even such vague terms is to subject it to closure also). Closure is a form of fixing that which was previously in flux, no matter how provisionally, of making actual that which was previously the merely possible. Or as he remarks: 'It is through closure that openness is divided into things.' He goes on:

> Closure enables us to realise objects of every type and
> variety. Closure is responsible for our being able to describe
> the atoms of hydrogen and the molecules of water that make
> up the sea; for our being able to experience a sunrise over

a field of corn; or hear the sound of a log fire and the warmth that it brings; it is closure that makes possible the kiss of a lover or the pain of injury; closure that allows the crossword puzzle and its solution; the words of language and the meanings they offer; Newton's theory of gravity and Shakespeare's sonnets; the state of peace and the activity of war; a society based on democracy; the universe; its beginning and its end. Without closure there would be no thing.[24]

There are many different levels of closure however. We might think of our immediate perception of the world as being fairly primary in this regard, although this too is based upon many previous closures about which we can do little — our physiology for example. In fact it is almost impossible to think of any area in which we can directly engage with openness and perform an act of closure upon it, as we tend to engage with that which has already undergone closure. We interact with people, consider ideas, engage politically, all of which are forms of closure, like anything else in fact, like anything we can conceive of at all. It is all material. As we can see, then, even that which has come about through a process of closure still retains the possibility of further closure and, consequently, retains a degree of openness. Writing is a form of human activity and, as such, has already passed through many degrees of closure, and yet that does not prevent it allowing an almost infinite number of subsequent closures, different languages, different forms, different styles, different texts.

Art is a form of closure, too, albeit an unusual one. It is a form of closure in that it is an area of human activity, and one about which we have some sense of understanding, no matter how confused, uncertain or complex. Yet it is unusual in that it is a form of closure that tries to engage with openness, which encourages openness. As an activity, art is perhaps more open than any other; anything could be claimed as art and many things already have been. Art is a form of closure that contains every form of human activity, and everything that is not human also. It could be argued, in fact, that art is the thing that most resembles what we could possibly imagine as openness. Perhaps this is why we value art so highly; it is its immense potential that appeals, the possibilities that it makes available to us. It is not that within art closure is abandoned, but rather that it is postponed, 'delayed', as Duchamp might have said. We value art that allows us to enact our own closures, and not an art that is closed upon arrival.

This is true of all good art, and it is certainly true of Fraser's. His is not simply an art about the world, but an art that is in the world, and one that becomes part of the world. It is a closure that moves towards openness, and that allows, implores and incites us to do the same.

Notes

1 Private communication with the author, undated (February 2002)
2 Interview with the author, 21 April 2002 and 28 April 2002. Unless otherwise noted, all quotations from the artist are taken from this interview.
3 Quoted in Robin Jarvis, *Romantic Writing and Pedestrian Travel* (Basingstoke: Macmillan, 1997), ix
4 Eric J. Leed, *The Mind of the Traveller: From Gilgamesh to Global Tourism* (New York: Basic Books, 1991) quoted in ibid., p.68
5 Thomas A. Clark, 'In Praise of Walking', in *Distance and Proximity* (Edinburgh: Pocketbooks, 2000), p.18
6 Ibid.
7 Quoted by Rupert Martin in 'Peter Fraser, Photographs 1983–1986, In Close Up', in Peter Fraser, *Two Blue Buckets* (Manchester: Cornerhouse, 1988), n.p.
8 Quoted in George J. Leonard, *Into the Light of Things: The Art of the Commonplace from Wordsworth to John Cage* (Chicago: University of Chicago Press, 1994), p.133
9 Quoted in ibid., p.59
10 David Brittain, 'Mirror with a memory: thirty years of writing in Creative Camera', in David Brittain (ed.), *Creative Camera: Thirty Year of Writing* (Manchester: Manchester University Press, 1999), p.15
11 Ibid., p.13
12 Ibid.
13 'Past Caring: An interview with Paul Graham' in *Creative Camera* (February1986). Reprinted in ibid., pp.133–135
14 Susan Butler, 'From today black and white is dead' in *Creative Camera* (December 1985). Reprinted in ibid., pp.121–126
15 Umberto Eco, *The Open Work* (Hutchinson Radius, 1989), p.104.
16 Ian Jeffrey, 'Unrepentant Roses – Two Blue Buckets by Peter Fraser', in *Creative Camera* (December 1988)
17 Quoted by Rupert Martin, in Fraser, op. cit.
18 T.S. Eliot, 'Imperfect Critics', in *The Sacred Wood* (Methuen: London, 1974), p.31
19 Quoted in Leonard, op. cit., pp.127–8
20 Ibid., p.128
21 Ibid., p.135
22 Quoted in Murray S. Campbell, '"An Enjoyable Game": How HAL Plays Chess', in David G. Stork (ed.), *HAL's Legacy – 2001's Computer as Dream and Reality* (Cambridge, Mass: MIT Press, 1997), pp.82–3
23 Hilary Lawson, *Closure – A Story of Everything* (London: Routledge, 2001), p.165
24 Ibid., p.4

Two Blue Buckets

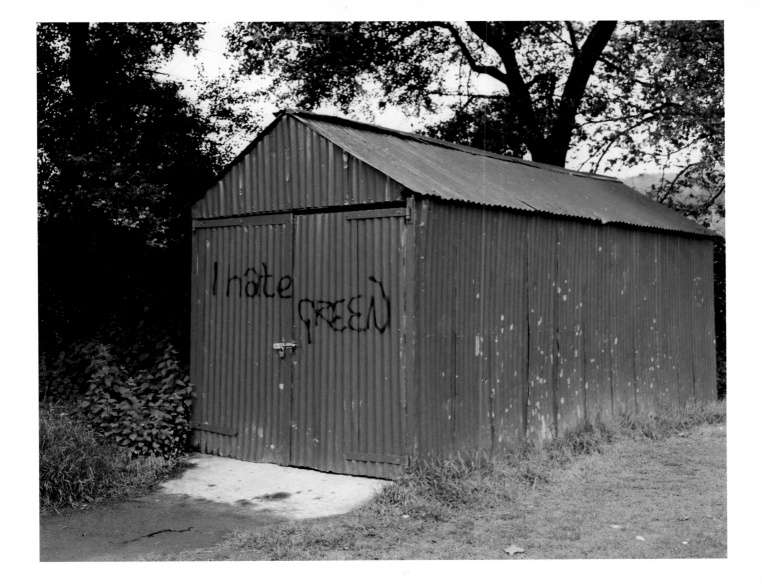

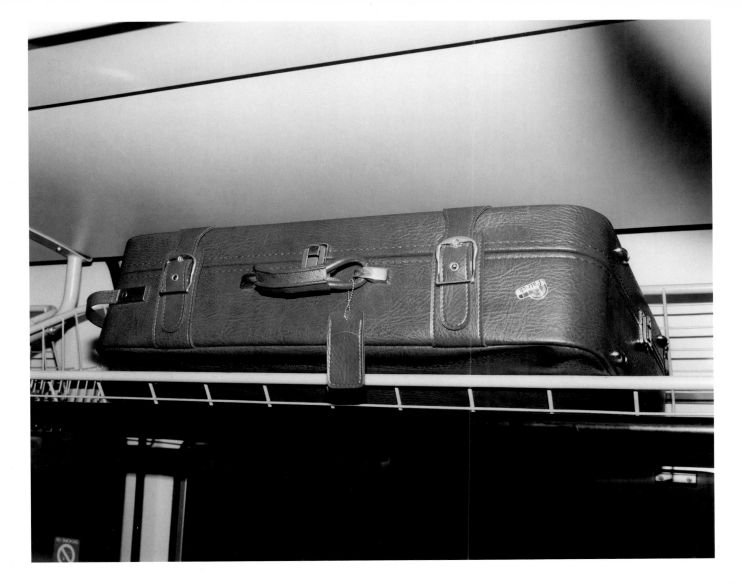

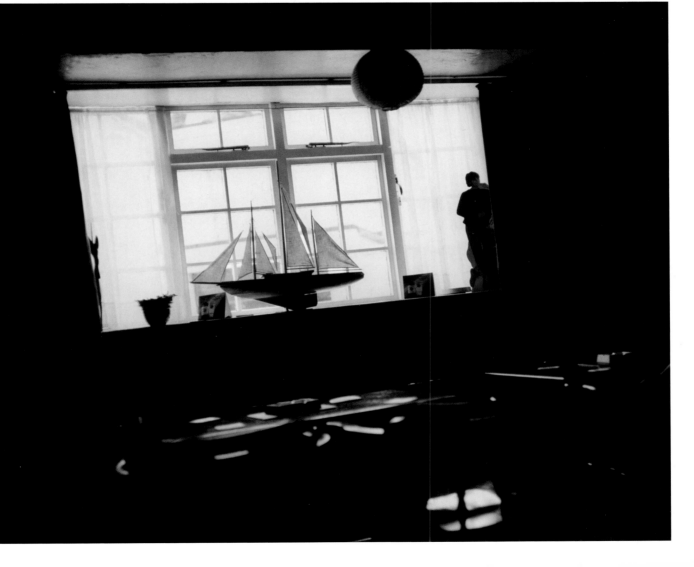

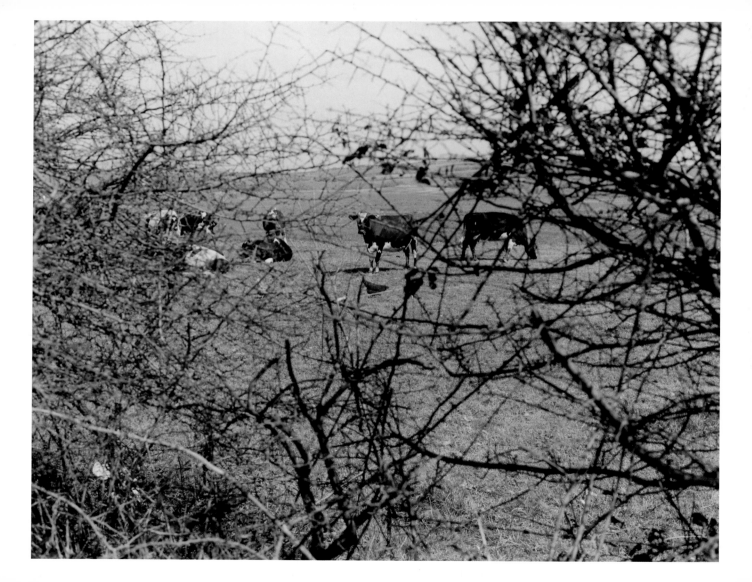

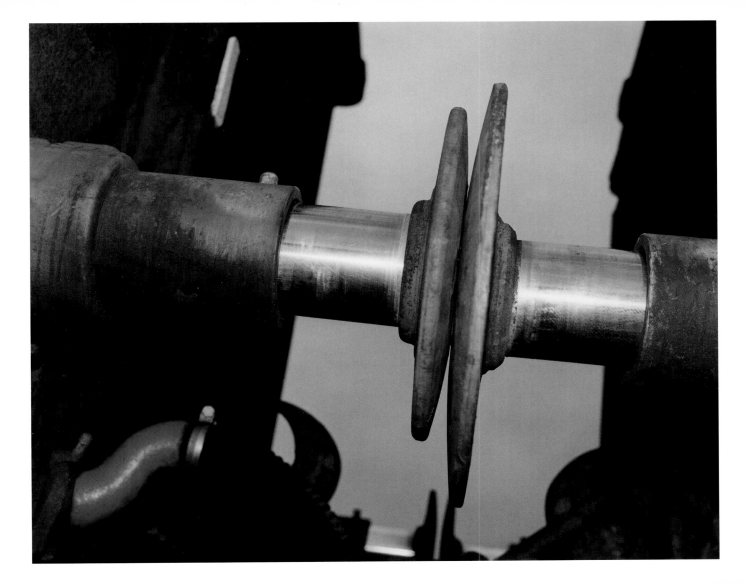

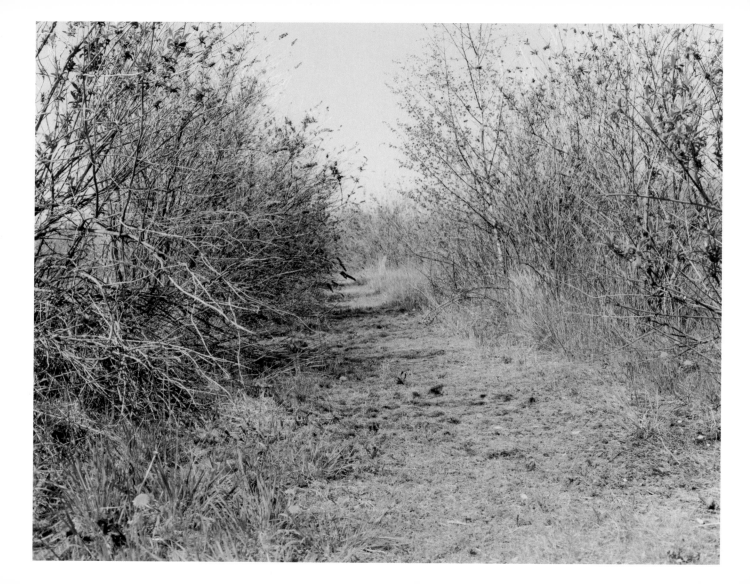

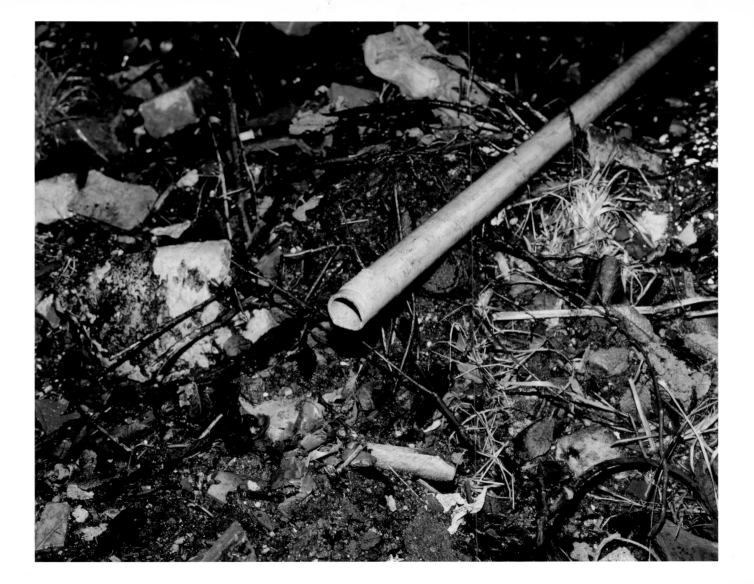

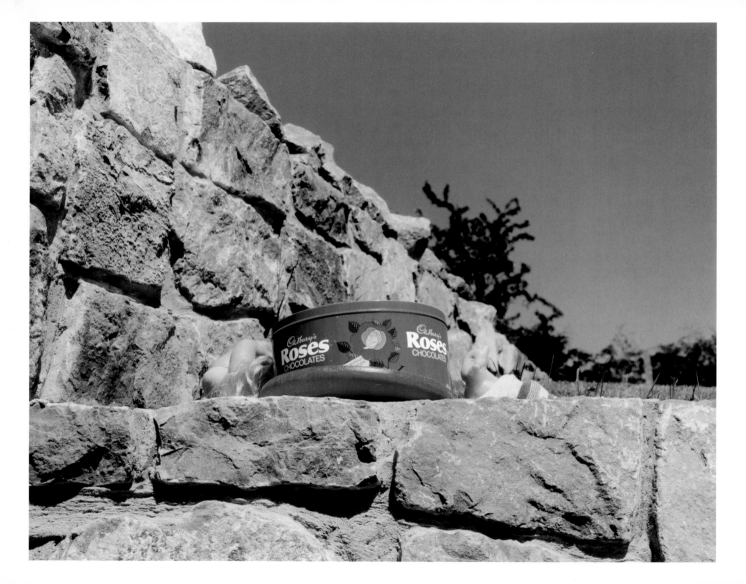

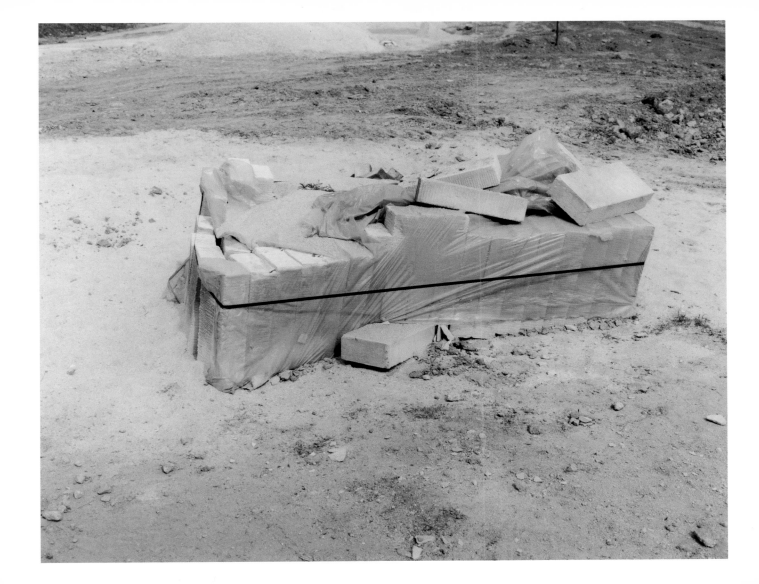

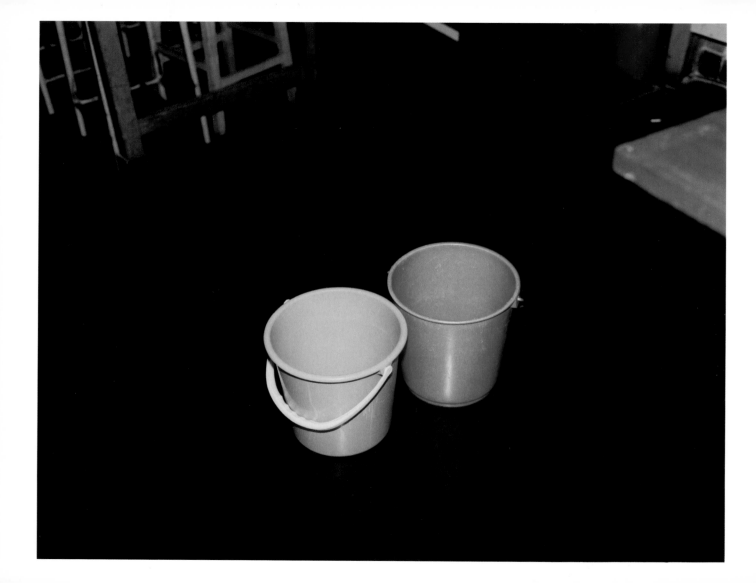

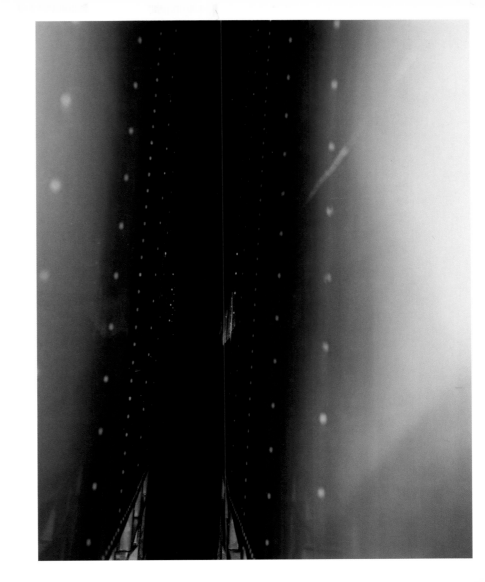

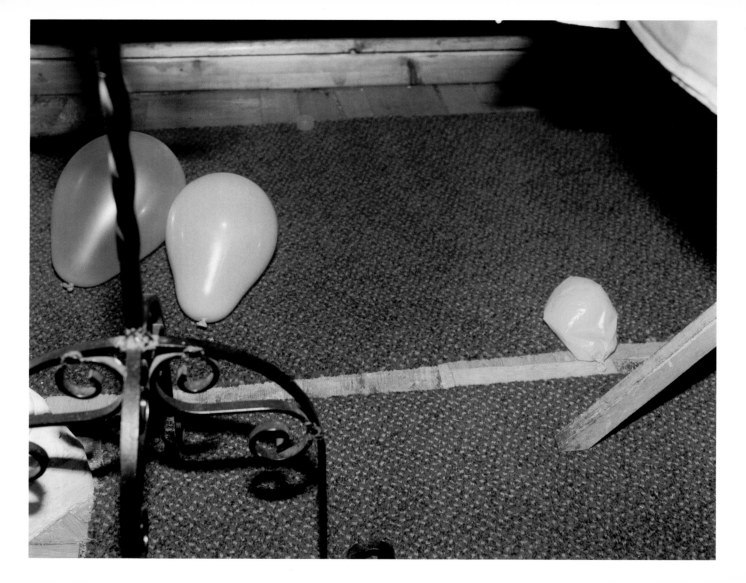

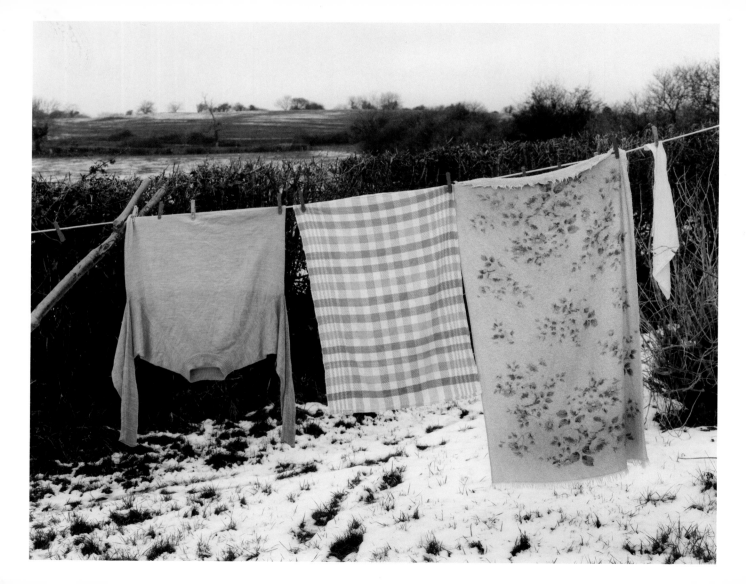

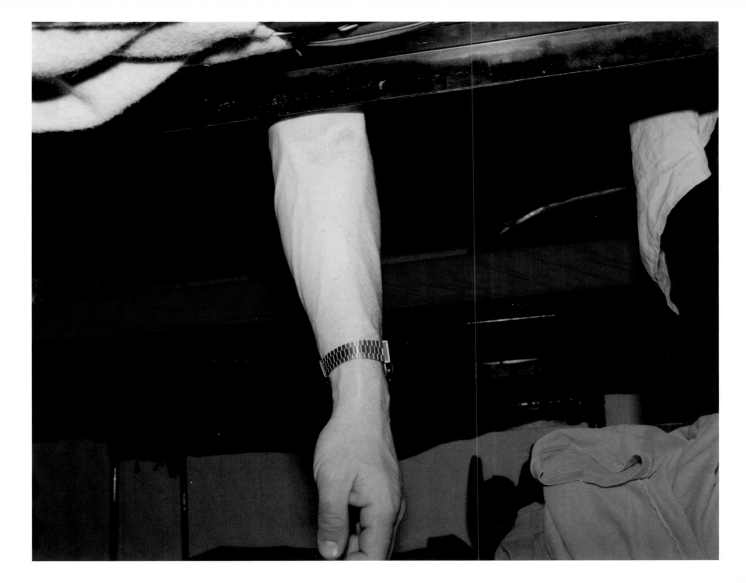

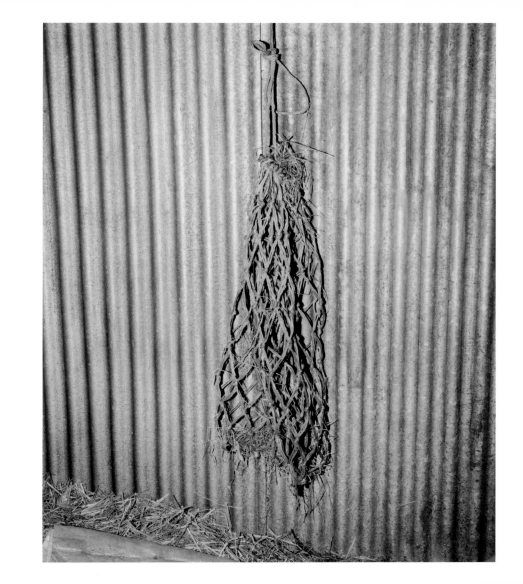

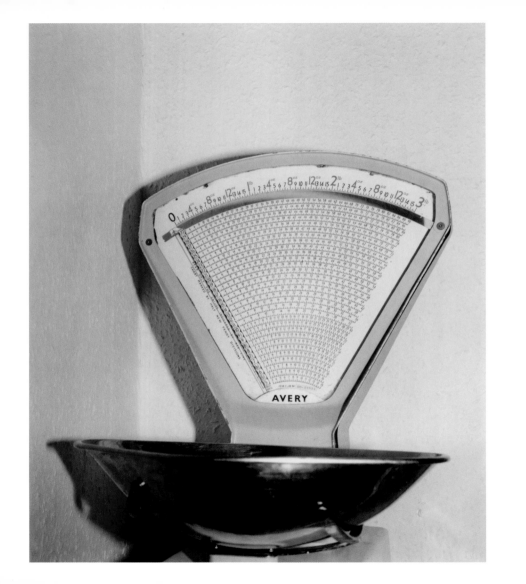

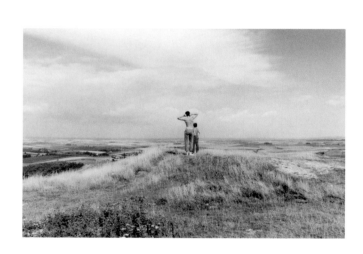

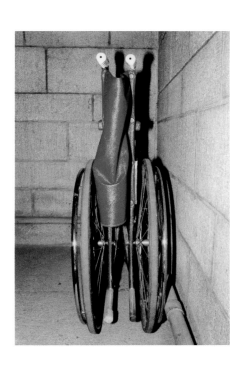

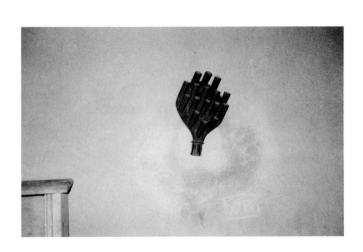

Triptychs

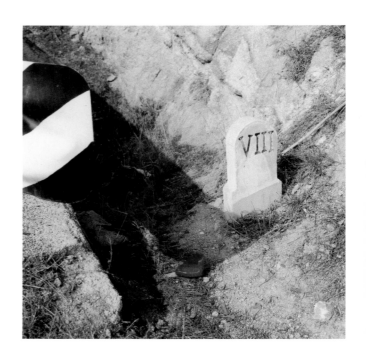

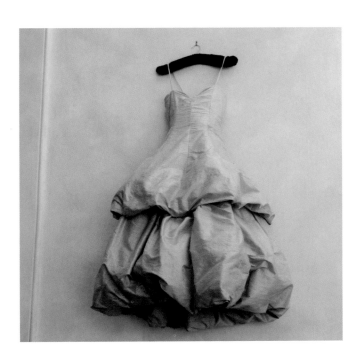

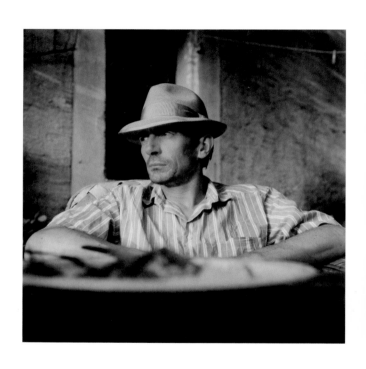

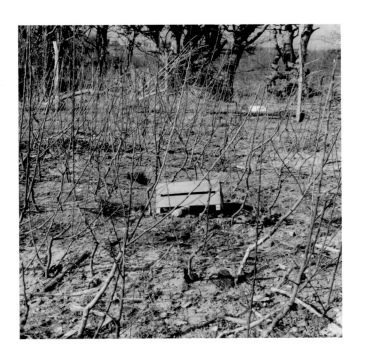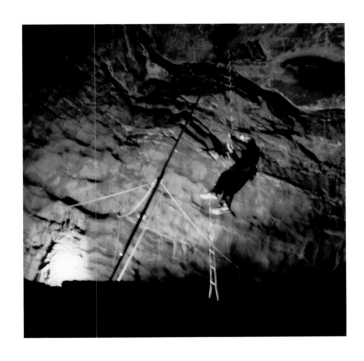

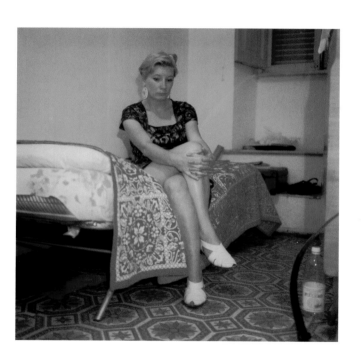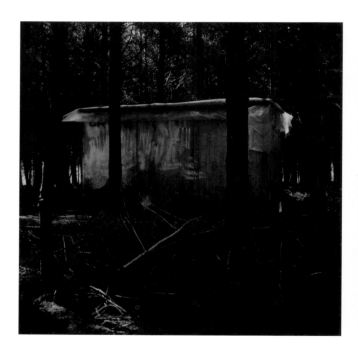

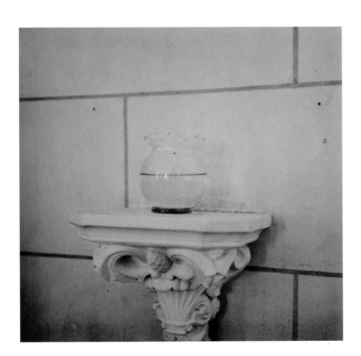

Ice and Water

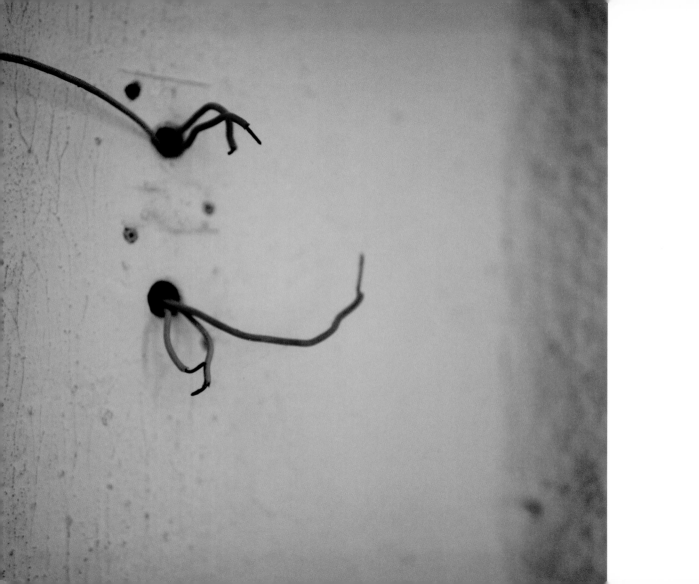

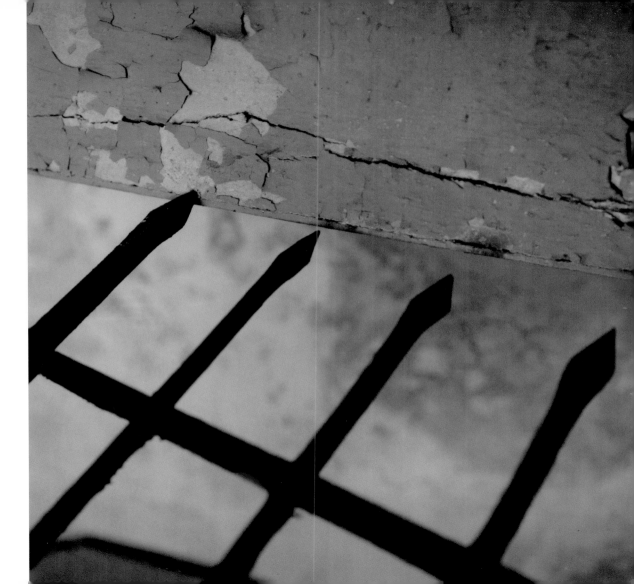

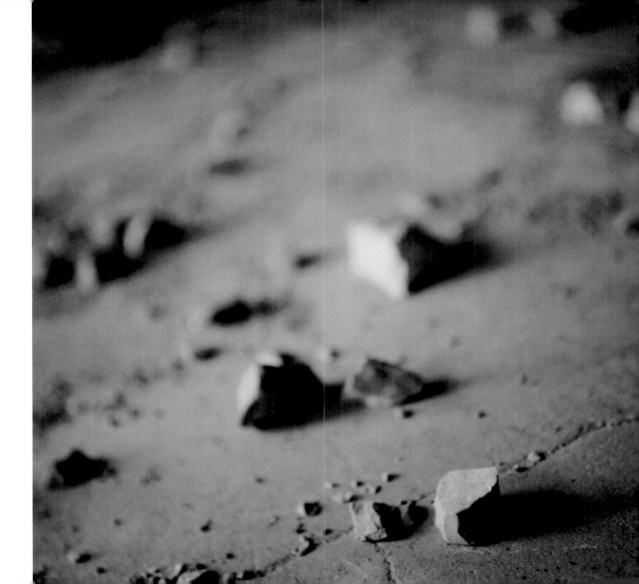

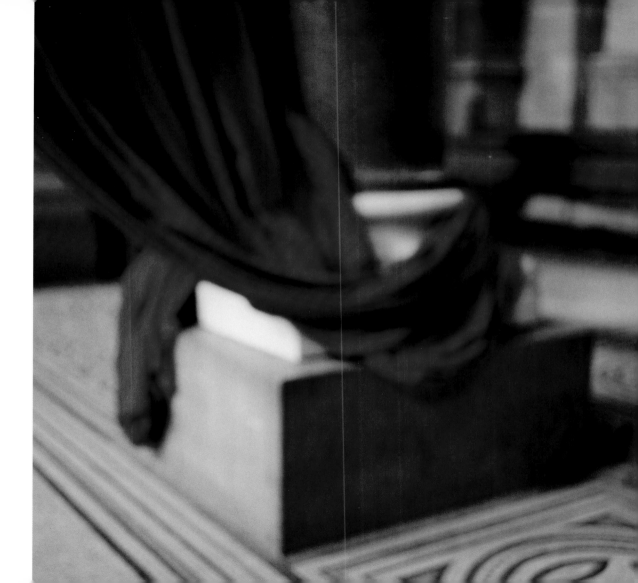

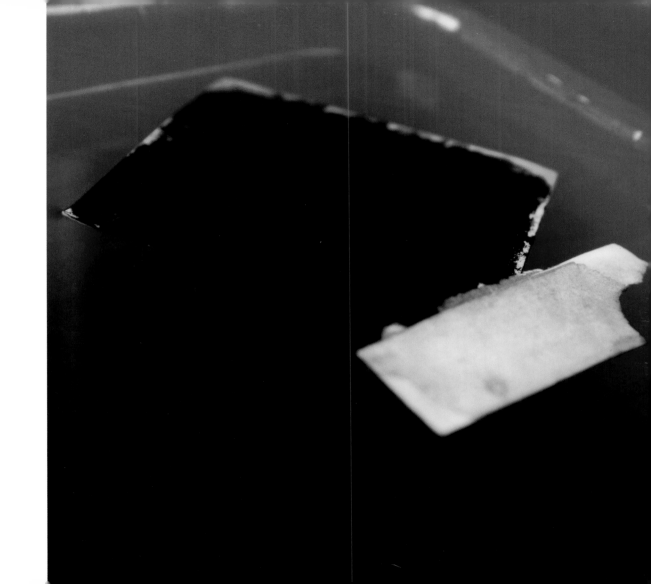

Deep Blue

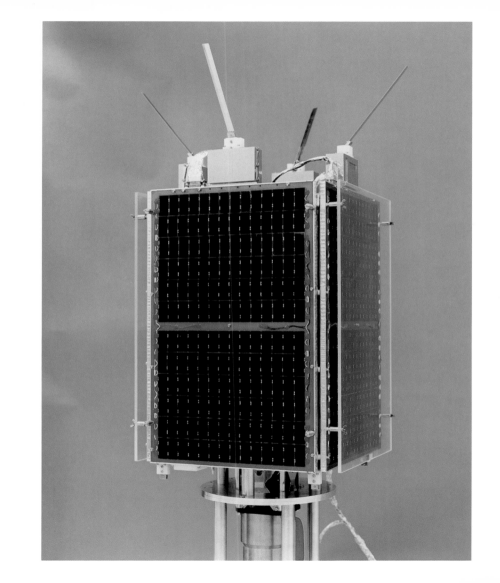

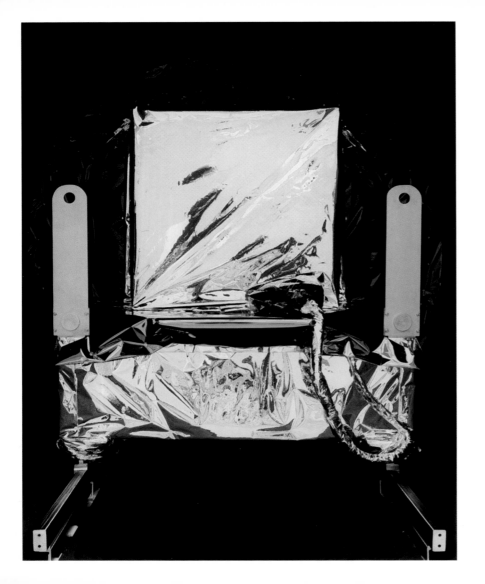

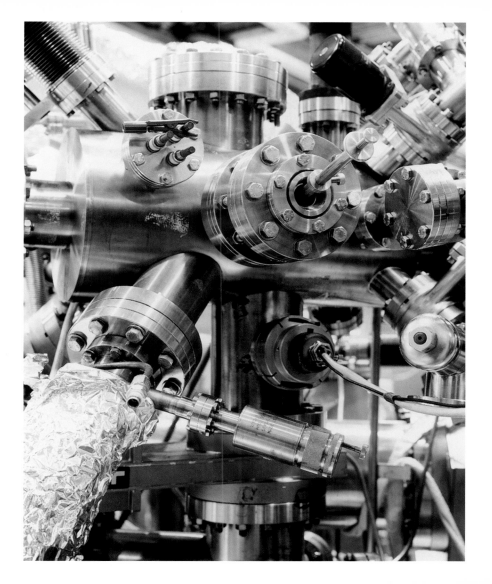

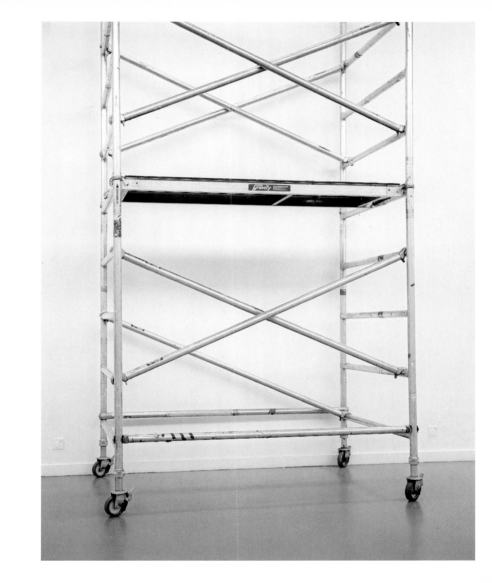

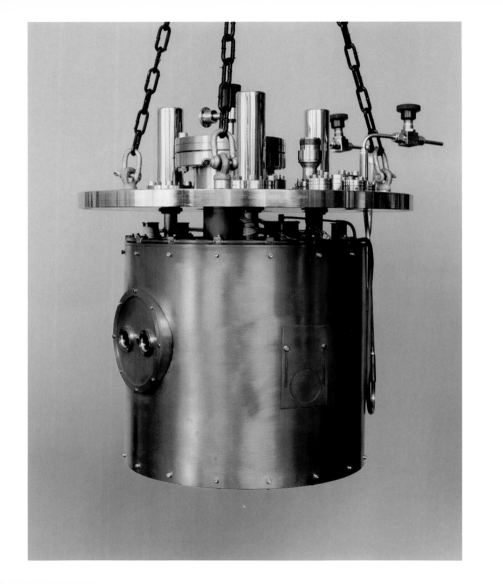

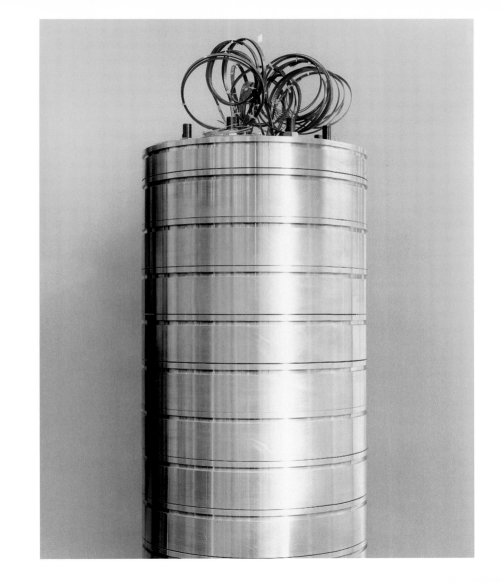

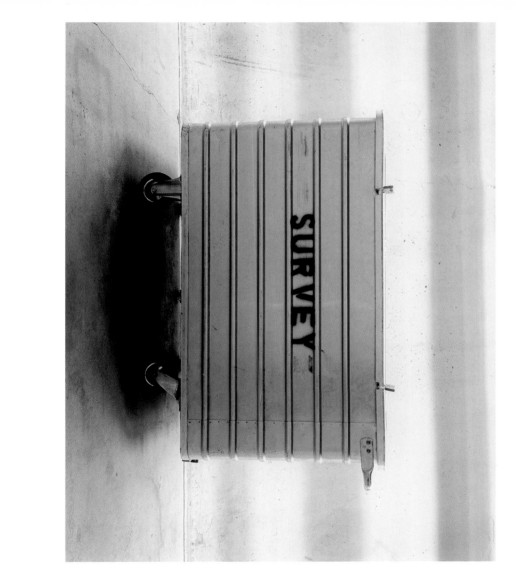

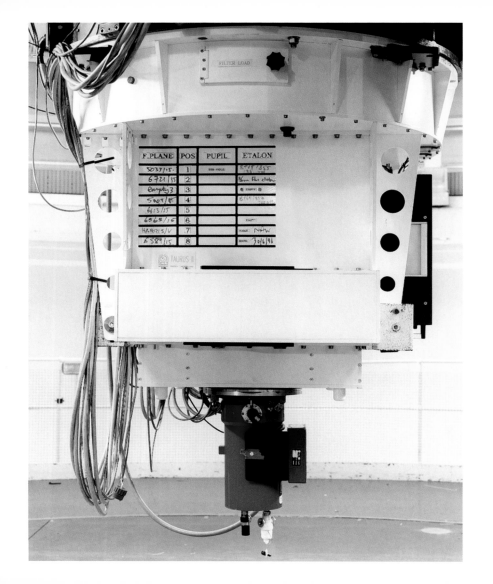

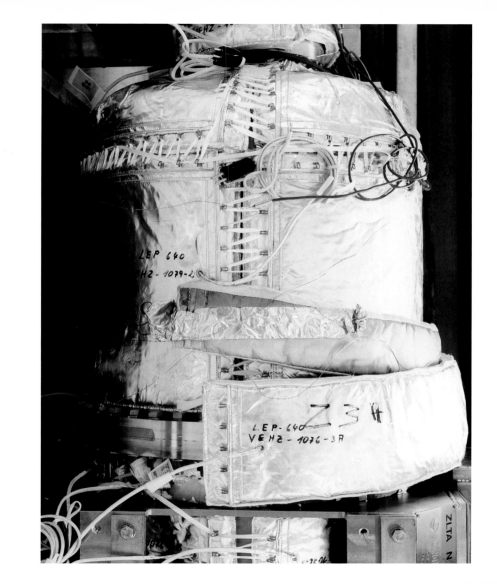

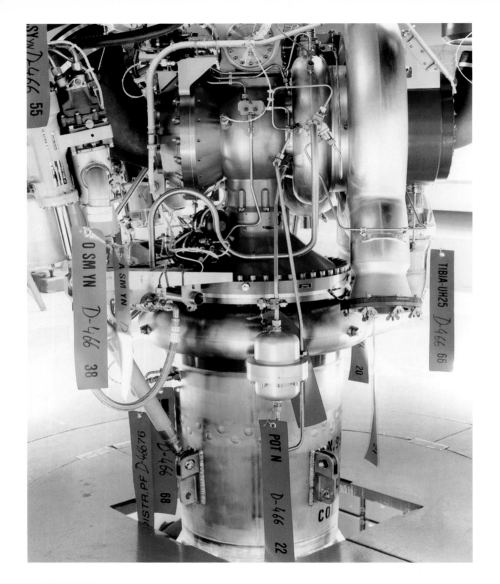

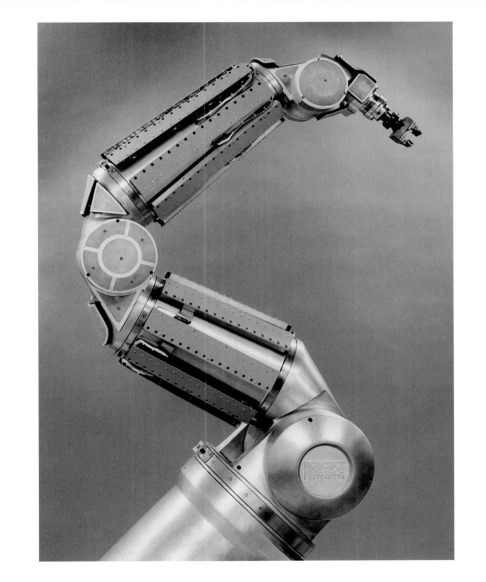

Material

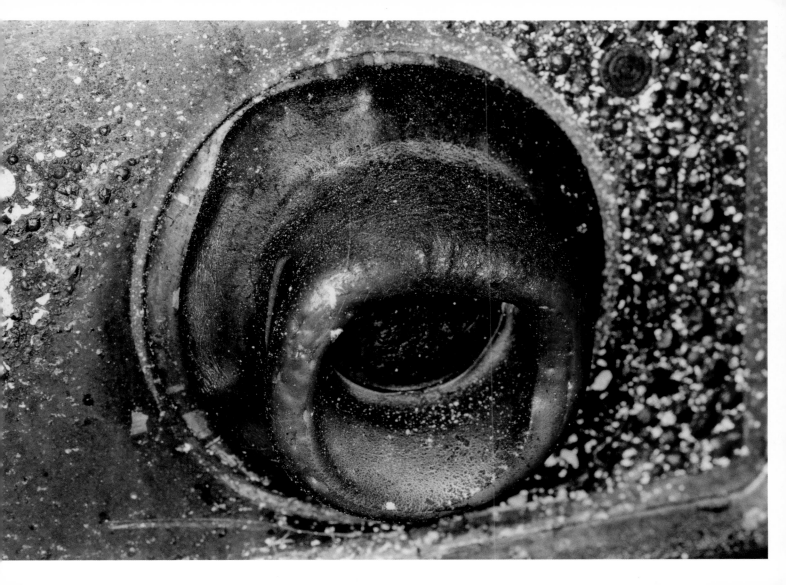

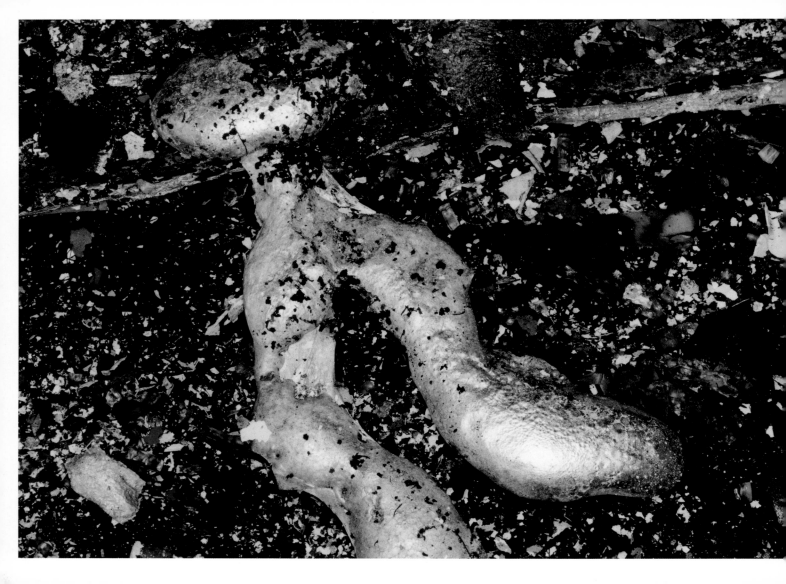

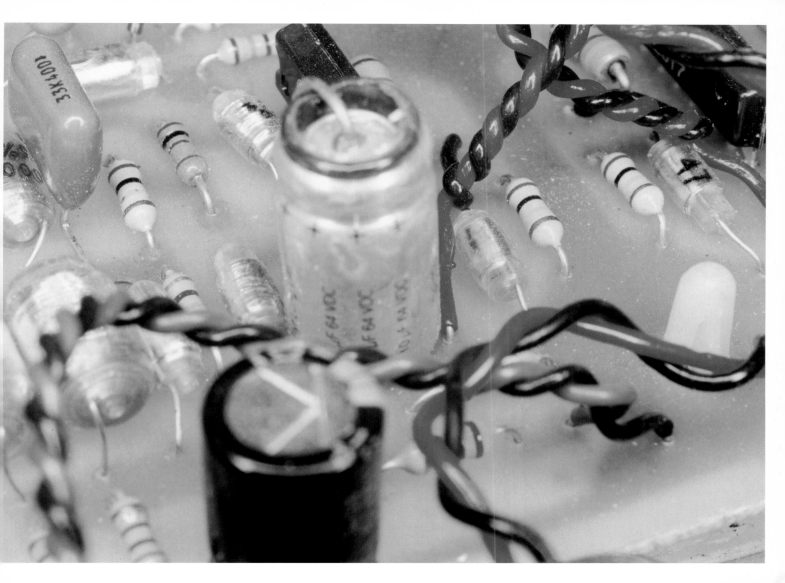

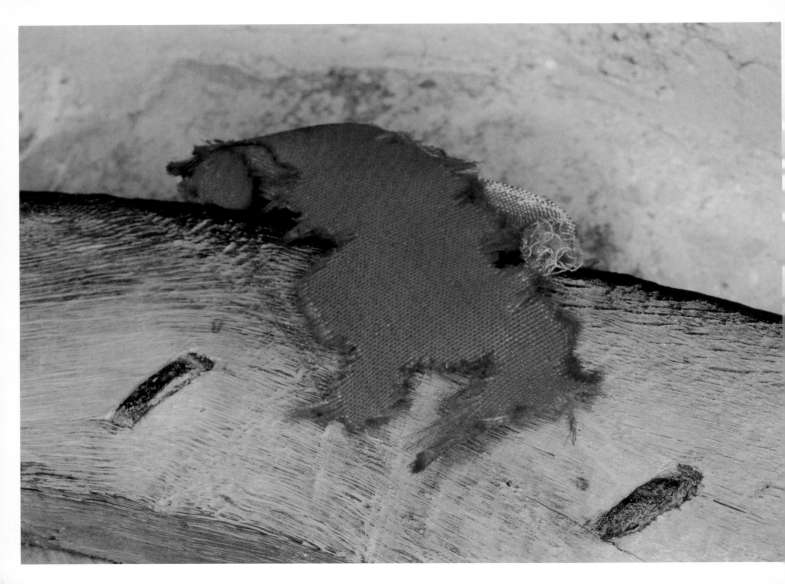

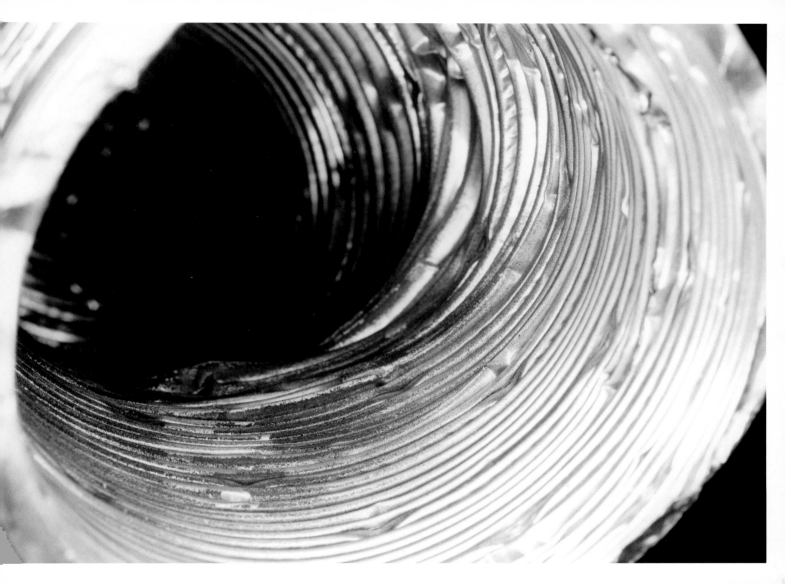

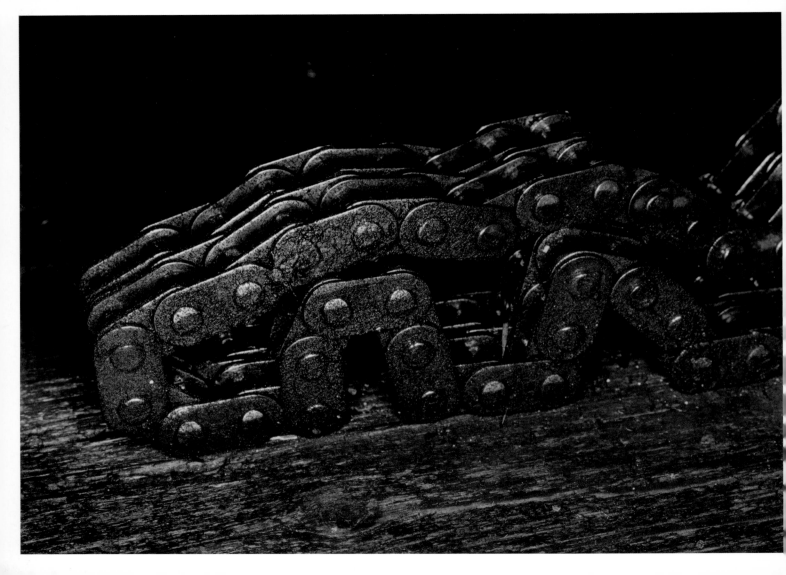

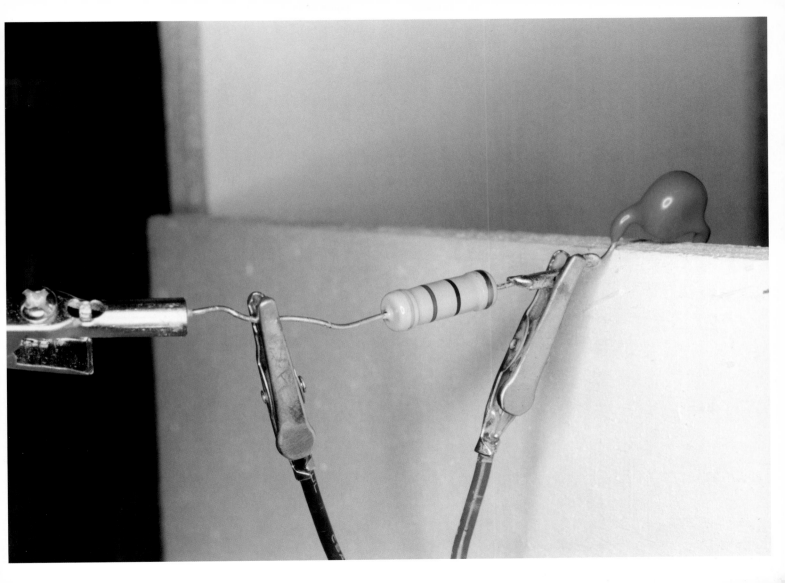

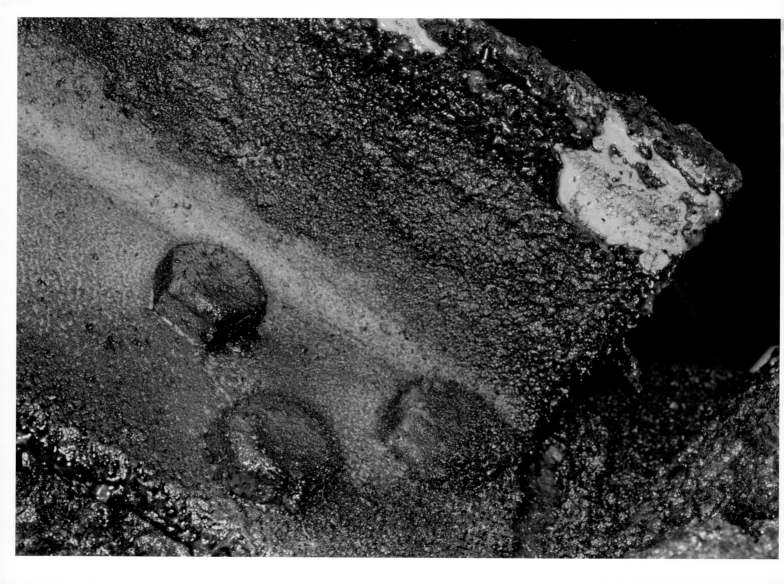

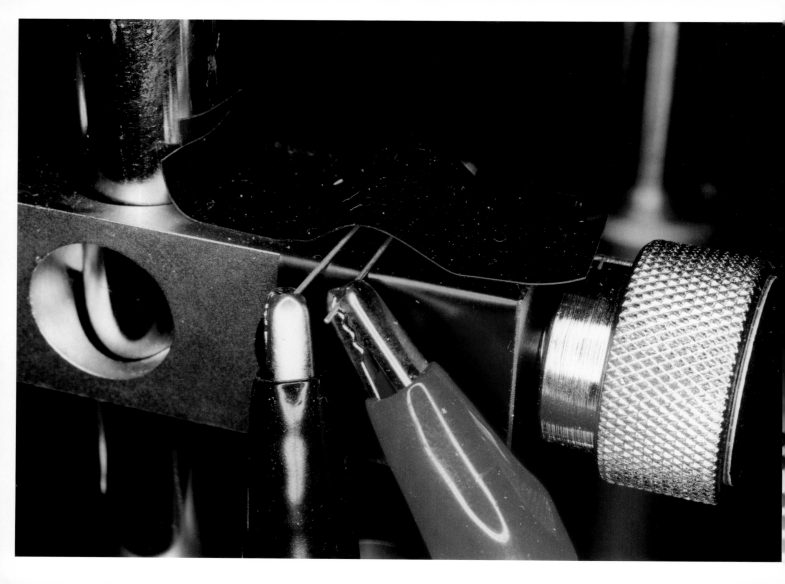

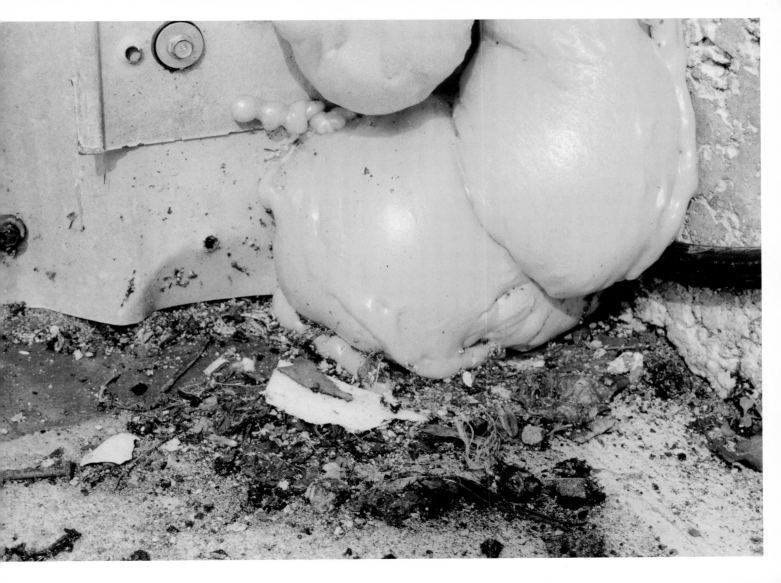

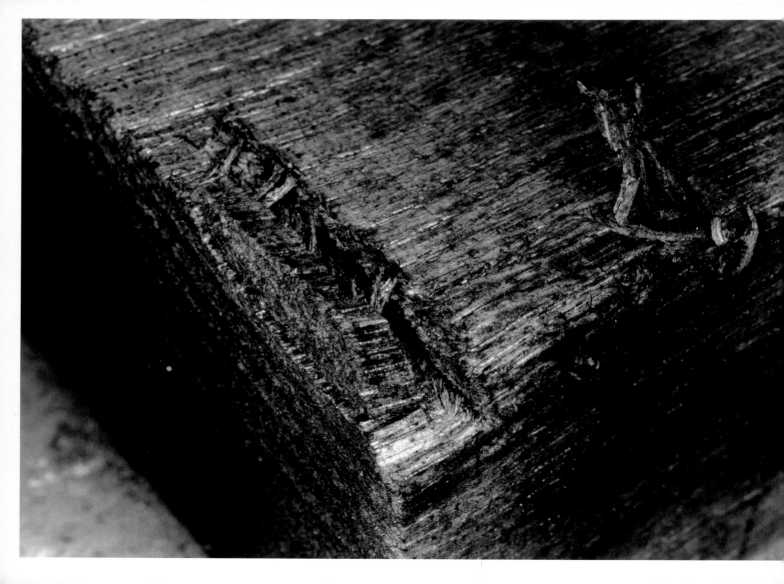

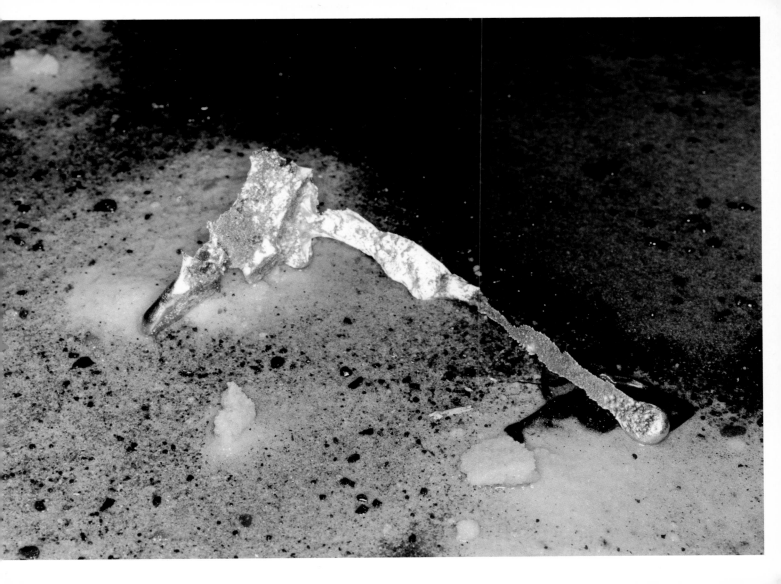

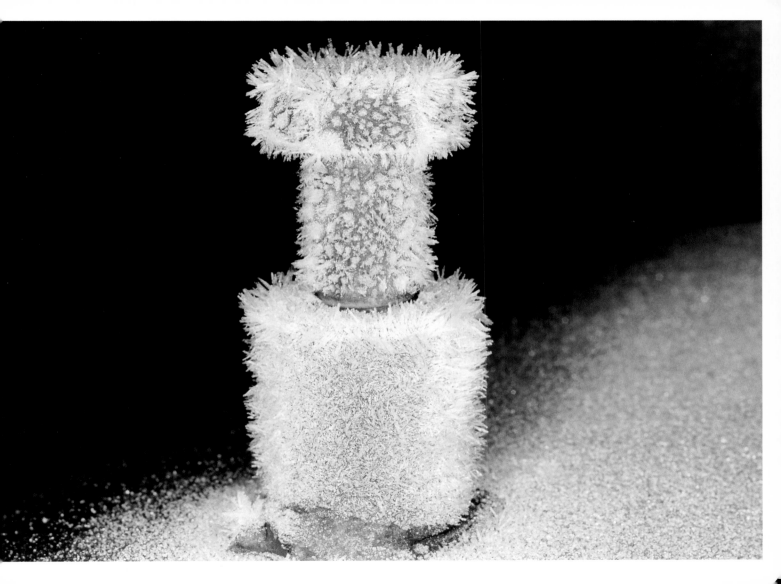

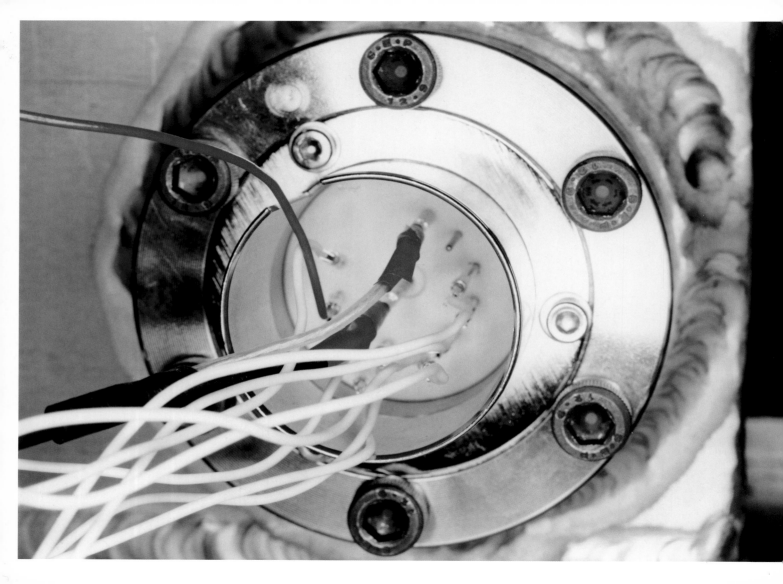

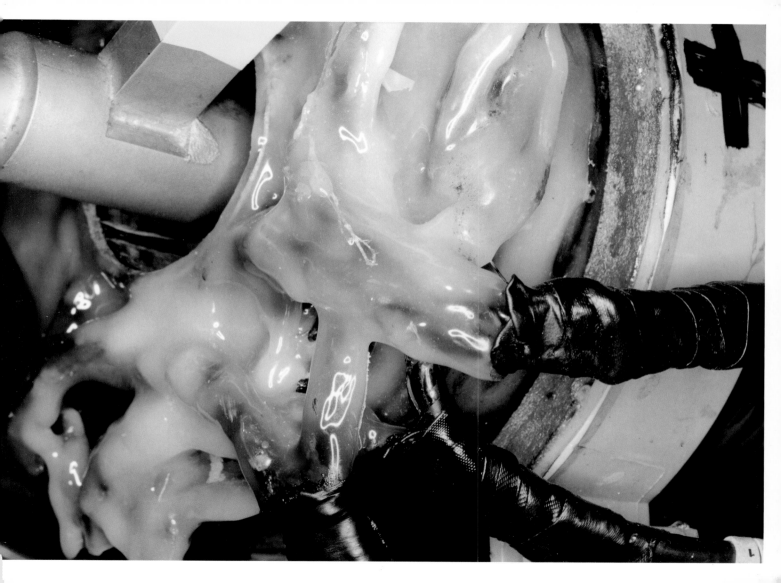

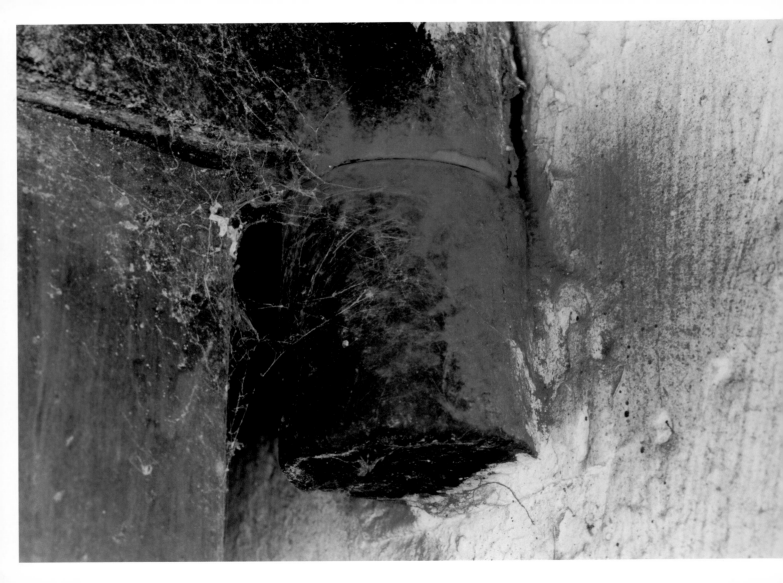

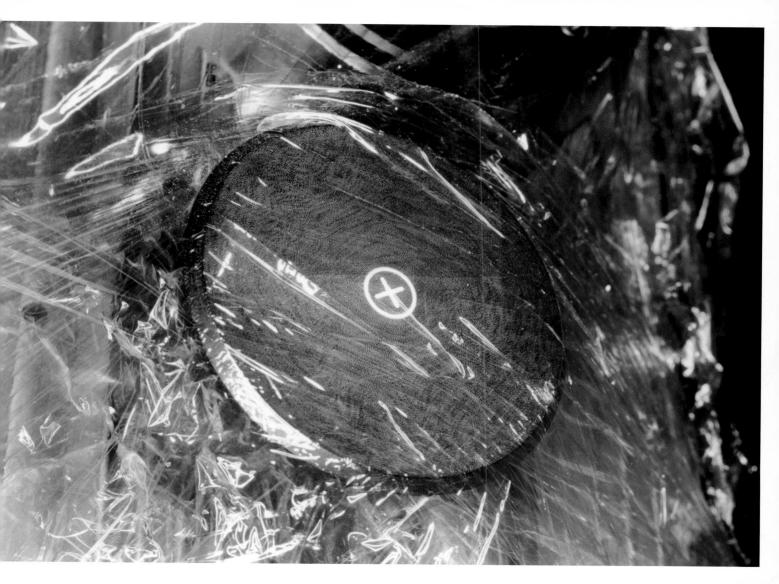

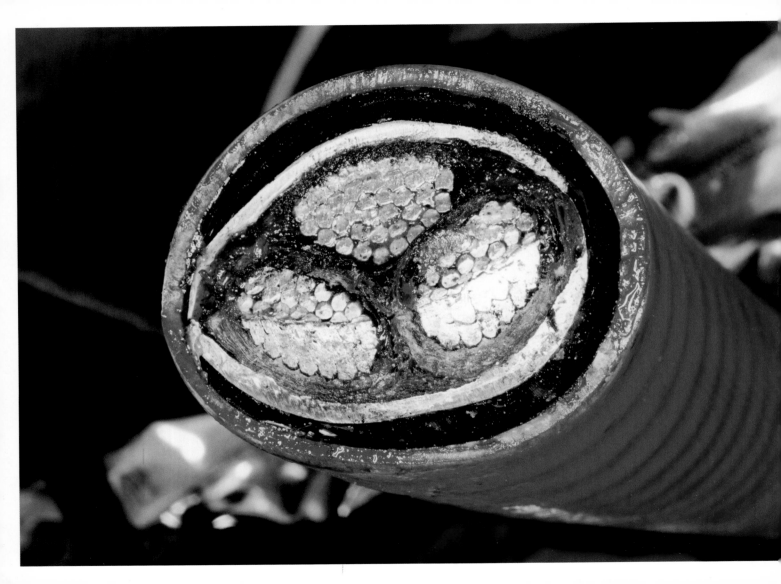

Peter Fraser
Born 1953
Lives and works in London

One-Person Exhibitions

2002	The Photographers' Gallery, London.
1999	213 Gallery, Paris, France.
1997-1998	*Deep Blue,* Viewpoint Gallery, Salford; Ffotogallery, Cardiff; Cambridge Darkroom; Tullie House, Carlisle.
1996	*Deep Blue,* Stephen Friedman Gallery, London.
1995	*Ice and Water,* St Louis Museum of Art, Missouri, USA.
1994	*Ice and Water,* James Hockey Gallery, Farnham.
1993	*Ice and Water,* Cornerhouse, Manchester.
1989	*Triptychs,* Interim Art, London.
1988	*Towards an Absolute Zero,* Watershed, Bristol; Plymouth Arts Centre, Plymouth; Ffotogallery, Cardiff.
1987	*Spectrum Galerie,* Sprengel Museum, Hanover, Germany.
1986	*Everyday Icons,* The Photographers' Gallery, London; Photo Gallery Hippolyte, Helsinki, Finland; toured the United Kingdom.
1985	*12 Day Journey,* Harris Museum and Art Gallery, Preston; Axiom, Cheltenham.
1984	*New Colour,* Oldham Art Gallery; Arnolfini, Bristol.
1983	*New Colour,* The Photographer's Corridor, University of Wales, Cardiff.
1982	*The Flower Bridge,* Impressions Gallery, York.

Selected Group Exhibitions

2001	*Nothing* exhibition, Northern Gallery for Contemporary Art, travelling to the Contemporary Art Centre, Vilnius, Lithuania, and the Rooseum, Malmo, Sweden.
1998	*Summer Show,* Stephen Friedman Gallery, London.
1994	*Institute of Cultural Anxiety: Works from the Collection,* ICA, London.
1993	Patrick de Brock, Antwerp, Belgium.
1992	Galerie Jennifer Flay, Decouvert Art Fair, Paris, France.
	Mehr Als Ein Bild, Sprengel Museum, Hanover, Germany.
1991	*Pamela Golden, Marcus Hansen, Peter Fraser,* Interim Art, London.
	Curt Marcus Invitational, Curt Marcus Gallery, New York, USA.
1990	Interim Art, London.
1989	*Foto Biennale Enschede,* Rijksmuseum Twenthe, Enschede, Holland.
	Through The Looking Glass, Barbican Art Gallery, London.
	Photo-Sculpture, Watershed, Bristol.
	Recent Acquisitions, Hayward Gallery, London.
1988	*A British View,* Museum for Gestaltung, Zurich, Switzerland.
	Towards a Bigger Picture, Victoria and Albert Museum, London.
1987	*Inscriptions and Incidents,* A British Council Exhibition, P.R.O.K.A, Ghent, Belgium; toured to Luxembourg, Italy and Germany.
	Sun Life Photography Awards, National Museum of Photography, Film and Television, Bradford.
1986	*I Hate Green,* The Ffotogallery, Cardiff.
	New British Documentary, Museum of Contemporary Photography, Columbia College, Chicago, Illinois, USA.
	The Animal Show, The Photographers' Gallery, London.
	50 Years of Modern Colour Photography, Photokina, Cologne, Germany.
1985	*A Sense of Place,* Interim Art, London.
	Image and exploration, The Photographers' Gallery, London.
	Axiom Review, Axiom, Cheltenham.
	Young European Photographers, Frankfurter Kunstverein, Frankfurt, Germany.